The Trade of the Teacher

Rembrandt, *Bathsheba at her Bath* (detail), 1654, oil on canvas, 798 × 800, Paris, Musée du Louvre.

Rembrandt, *Bathsheba at her Bath* (detail), 1654, oil on canvas, 798 × 800, Paris, Musée du Louvre.

Rembrandt, *Bathsheba at her Bath* (detail), 1654, oil on canvas, 798 × 800, Paris, Musée du Louvre.

Jeroen Lutters

vis-à-vis

Valiz

The Trade of the Teacher

Visual Thinking with Mieke Bal

If you lose art you lose culture; if you lose culture, you die.

—Mieke Bal

Contents

7 Preface
11 Prologue
19 Introduction: What is a Teacher?
39 Narratology: A Mode of Expression
61 Close Reading: A Methodology of Openness
87 Travelling Concepts in the Humanities: An Approach of Doing
119 Preposterous History: A Need for Creativity
139 Epilogue

149 Literature
153 Index
156 Biographies

Preface

Mieke Bal is a well-known Dutch professor of cultural analysis, with a long history of teaching in the arts and the humanities. During four afternoons in June 2016 we engaged in a conversation on the art of teaching. In looking for answers, I brought in paintings by Banksy, Rembrandt, Marlene Dumas, and George Deem as 'teaching objects'.

 I asked Mieke what these paintings might have to say about teaching. The result was the present text, the 'Mieke Bal Afternoon Interviews'. A text about teaching the arts and the humanities in a way I had never heard of before. I hope *The Trade of The Teacher*—the title is a quote from Mieke—will serve as a source of inspiration to students and teachers, especially in the arts and the humanities, who are longing for a counter-voice in a complex educational arena. This text makes clear how objects can speak, how they are thought-images, how we can use them, how they teach us, in finding answers to important questions, just by looking, listening, reading, in the triangle of student, teacher and teaching object.

—Jeroen Lutters

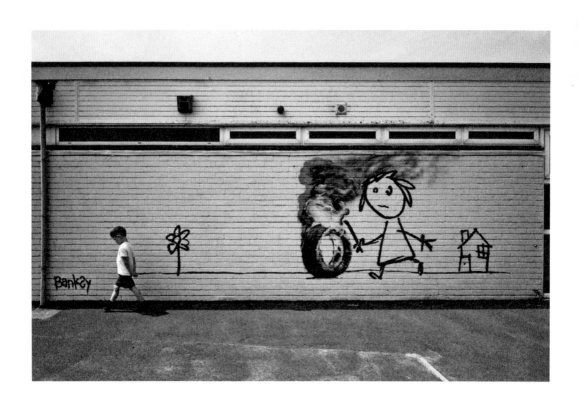

Banksy, *Bridge Farm Primary School Mural*, 2016, 1350 × 2048 cm, Bristol.

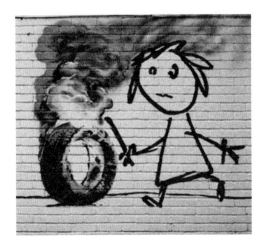

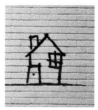

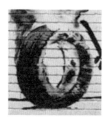
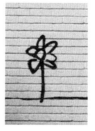

Prologue

Even as a child, my siblings teased me that I was always teaching. That it was something I was born to do. But teaching, in my experience, is nothing like lecturing *at* people; it is communicative, sharing the excitement of discovering how things work. Also, disagreeing seemed almost a hobby; discussing a favourite pastime. Hence, I started to teach a soon as I could and I have done so at all levels: from middle school to high school to college and university, at the levels of BA, MA, and PhD.

Narrative Pictures

A brilliant mural. Amazing. I think it is totally educational. Totally. Something is happening, that makes it narrative right away, so it's clearly a narrative picture. What is happening is a combination of a childish joyful aesthetic and some horror. I mean,

you immediately think of the murders of African blacks with tires around their necks. When I see a tire burning, I think of that, and I smell the combination of burning rubber and burning flesh. In the second instance, I think of the burning of cars in riots, but then I already take a step away from the horror. However, the fun thing is that she is supposedly pushing the tire with that stick in the direction of the flower, but not quite, because the flower is standing on this edge and the tire is rolling in a slightly different direction. This is why it is so narrative.

Visual Representation

The artist is using the laws of visual representation, such as perspective, to make several points, and one is that this child, this little girl could easily be in danger, but she could also be a danger to others because she is pushing a burning tire. Would she also be a danger to the flower? Without the flower, the painting would be a bit empty; the flower makes it a big painting. The flower also suggests there is an afterlife. This moment, the house, the scale; it is a lovely picture because it plays with scale in a way I'm constantly seeing in Edvard Munch. It is an excessive reduction of size, which suggests that this is an immense space. The house is very far away, so the

child, if she came out of that house, is way too far from home. She is in danger because of that. She may just get lost or even be abducted, raped, or run over by a car. Something really bad will happen because she is not close enough to her house, which is why the house is so small. Now, the flower is much bigger, it is even bigger than the house, so that she is more to the forefront, but the tire—and this is the interesting thing of course—the tire is photographic. I don't know if it is painted in or what. It's a very different aesthetic from the childish drawing, so it is alien to her. The tire is not hers, it is not part of her world. Therefore, you could think—because of her facial expression, which is not so clear—that she encounters this tire and decides to take it along. Maybe to take her revenge on people who have been nasty to her. So, you start to speculate, but basically, I think it is the clashes in the aesthetic, in the scale, in the perspective and non-perspective that make it strange, because she is also just standing on a line and she is actually stepping over that line.

Teaching Children to Think
I hope they leave it on the school wall, because this kind of thing can induce children to think, even little children. Don't you agree? What is happening to this girl? What is she doing? What is happening? Is

she running away from a danger in the house and does she feel that the tire is less dangerous here than inside the house? Furthermore, it's so funny that in the signature the 's' is reversed, which is what kids do when they start to learn to write. This is a very touching thing; very touching. Boy, I have to go see it. This is aesthetics. It is incredible, and it is the little things that make it so. It is also of course an adult who identifies or better, empathizes with children, which is always touching. The little things like the house that is a bit sloppy, the two lines that form the roof go too far, the chimney that doesn't go far enough; as a drawing it is a mess but yet, as an artwork it is perfect. Everybody can see something different in it and I don't think that primary school children will necessarily see the scale problem.
For instance, the house is too small, the flower is too big and the girl is too big, but that is all still part of it. I think it is a beautiful, beautiful work. It is really incredible. I had no idea, but it's great; really lovely. I think this whole street art culture is very important, because it is so visible. It is also not elitist, because everyone can see it. It would never do to put it behind glass in a museum.

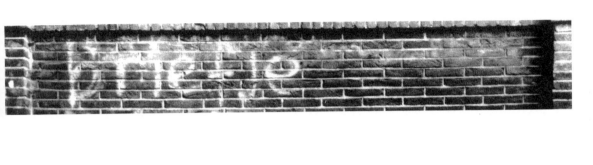

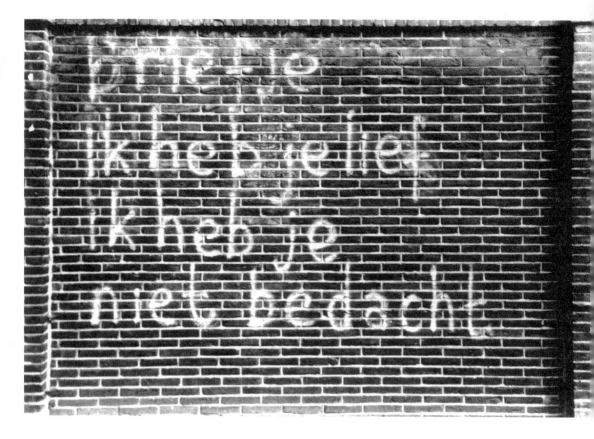

The graffitto or wall writing deconstructed in these pages is the emblem of the research institute ASCA that I founded some 25 years ago. It begins with the Dutch word 'briefje', meaning a short letter. The form of the text is an icon of the form of letters, beginning with an address, 'Dear so-and-so', followed by the 'body' of the letter. The word that has the shape of the address is self-referential. The word 'briefje' means 'short letter' or 'note', but it rhymes with 'liefje', a more usual form of address, meaning 'dearest' or 'sweetie'. This fits in with the beginning of the text itself that says 'I love you'. The discourse of the love-letter then shifts to epistemic philosophy when it continues: 'I did not make you up.' The statement of non-fiction is inherently contradicted by the address that changes a real person, the anonymous writer's beloved, into a self-referential description of the note.

This tension questions the distinction between fiction and reality the note/graffito thematizes. It also inscribes academic reflection at the heart of an expression of contemporary, 'popular' culture—the graffito, a handwriting on a wall in public space. Moreover, the body of the text is identical to the ending of a poem, 'Je bent' ('you are') by Dutch poet Ellen Warmond. Thus, the interdiscursive complexity of the text, connecting it to academic inquiry as well as, through this allusion, to 'high literature', doubles up with intertextual citation, specifically to women's literature of the 1950s.

The graffito was publicly accessible, semantically dense, pragmatically intriguing, visually appealing and insistent, and philosophically profound. Yet it stubbornly remained a transient thing that could disappear any moment—and it did. This, this accidentally found text-image—my only-ever published photograph—has in more ways than one come to stand for the programme of ASCA, the Amsterdam School for Cultural Analysis, that I co-founded in 1992 and of which I was the first academic director. MB

Introduction
What is a Teacher?

Teaching as a Privilege

Teaching is a privilege. It means that you have the pleasure and the privilege to be able to witness other people learn and be excited about what they learn and be empowered by it. I think for me that is the greatest pleasure. To see this 'ahhh, yes, I get it'. Actually, when you enumerate all these levels on which I have been teaching... When I started to develop narratology, which was when I was teaching in a Teacher Training College, I had a guinea pig. A girl in the fourth or fifth grade of primary school. She had no knowledge of any terminology, which was a great advantage for her. And she was interested in literature, she read a lot. So, I asked her parents if I could borrow their daughter for an intellectual experiment. I explained to her some aspects

of narrative without using any technical terms. Her grades in composition immediately skyrocketed, because she could make more variations in narrative structures; it was no longer 'and then, and then, and then', but she was able to see causal connections and divergences and other things I was discussing with her. No technical term passed my lips. It was completely about reading. I taught her focalization without ever using the term. I encouraged her to ask: 'Who is seeing this; how do they know that?' and those kinds of questions. This was wonderful.

Books

I felt astonishment and deep gratification, and asked myself why this young child was so open to this? I think she was nine or ten years old. She was so receptive because she was not burdened with other theories. I asked her to bring a book that she liked. She brought *Pietje Bell* or *Dik Trom*, I don't remember which one. One of those Dutch classics about naughty children. I remember a scene, I think it's in *Dik Trom*, when boys are spying on a woman who to them looks like a witch. I drew her attention to that spying. I asked her: 'How do they come by this judgement about the woman?' Because they are looking and they are interpreting what they see, but how can they know that? Can they know that?

Maybe they are wrong. And she said 'Oh, yes. Now I'm sure they are wrong because the woman hasn't done anything bad.' They think the old woman is a witch, because they have been spying through her window but they didn't quite see what she was doing inside her small house. I am more or less making this up now because I don't remember exactly how it went. I think they proceed to tease her because they think she's a witch. That frightens the unfortunate woman and she starts to scream. Then they run away because they are now convinced she is a witch and is going to turn them into geese or something. That is how perceptions turn into actions in the story.

Understanding

So, it was an exercise in understanding focalization without using the term. She was completely receptive to it, and started to practise it. Then I told her it was not only for reading but also for writing. For your next school composition, try to use this. Doing theory while not using the terms. In teaching children, what you need is not so much a toolbox with concepts but an understanding. And the understanding that they need is: how are stories made? How do they work? Why is it that in the middle of a sequence of events there is a moment that somebody

is perceiving what is happening and that can change what is going to happen next? Therefore, teachers need to have a similar understanding. They can use the concepts for themselves because it clarifies in their minds how this is probably put together, and how readers imagine it. This is important if you read a story. You can also see stories. You see how it is not just an actual sequence of events but how it becomes a story precisely through the input of characters who contribute, not by acting but by looking for examples; listening, hearing or smelling for examples, and then acting upon that. I think that is something that you can easily understand if you take an actual story and go line by line and say: what's happening here? Who is doing this? Who is doing what? What exactly are they doing? That is understanding.

Resistance

Understanding is a resistance against manipulation. I think maybe understanding would be following the story in detail, and seeing what and how it is put together so that you can see how the text also manipulates you into believing something. Just as the narrator also manipulates the characters into believing something. But if you see how you are being manipulated, you are no longer being manipulated. Then you have resistance. Understanding is a

resistance against manipulation. Therefore you don't have to do high theory for this. I think this child was so receptive to what I did simply because it was based on systematic thinking. And that is also a word that you would never use in class. But it is a systematic theory. And being systematic is a democratic tool, because it makes what you are explaining understandable for anyone. You don't need the terms; you don't need the scholarship; you can just understand what is happening. I think, for me, understanding is clear enough. Following the story line by line, following the language, but then also seeing through that, and jumping from here to there, and seeing where the story has gone in this passage in particular.

Communicative

Understanding in that way becomes itself communicative. The teacher and the students can talk about what is happening. If as a teacher you make a mistake, this is never a big deal; you can say 'I'm sorry, I made a mistake.' If you make a mistake with this systematic mind-set they can see themselves that you made a mistake. That is empowering for the students; it puts teacher and students on the same level, which is a condition for communication. Why are those boys looking through this old woman's

window? Because they have heard their parents talk about her. That is not an ontological question; that is just a causal question. What made them do it? And then you get the ideological background of stories. And understanding that becomes part of the package, of course; the goal is to resist manipulation, including accepting what other people say without thinking. Once these children have understood that they are wrong and this woman means no harm to them, they reverse their own thinking. I think it was in *Dik Trom*, but I am not sure. The point is that they have been manipulated into thinking: old woman alone in a house equals witch. All the old women alone in houses are going to be perceived as witches, because a woman shouldn't be alone. So, once they have this in their minds, they are going to see what they think they are going to see. And so, they see a witch because they think they already know she is a witch, because this was the ideology in the village. Once they have understood, this woman could show her frightened face, for example; or the boys could see such a face in their imagination. She turns around; she screams and she is frightened. They get that—focalization—and then they will stop harassing her. That is how the story can help effectuate an ideological reversal, you know, a counter-reading, neutralizing the previously instilled prejudice.

Democratic

Is there a difference between reaching that child and working with students? Well, it boils down to asking the same question. I'll try to explain how teaching should fundamentally be democratic. Not just because it is fairer and more just but also because it is intellectually more productive; because it enables learning. You can, for example, give the students their homework, saying: 'Here is the text, here is the passage. I want you to read this chapter and pay attention to what really matters; why is what happens happening?' Not 'why' in the sense of a god-sent determination or obligation but in the sense of causal relations. The characters do something and they have a reason for doing it. What is the reason that they do it and how do they find out that they are wrong? So, this is something you can give as homework. Then when the class meets, they are as smart as you are because they have prepared this exercise. You let them talk and then they will debate with each other. And they will even maybe argue and fight, and that makes for a lively class. It is very simple. You devise a structure for the class, for the seminar. First of all, for a seminar, for example, I think it is really important that there is a common basis in the sense that they read some texts assigned beforehand; all of them. And that each of the students brings what they have learned from those texts to

bear on their own research questions and objects. Therefore, they each have something that they alone have and something that they will wish to share— which they all have. And that is the basis of the democratic nature of the seminar. That they are all equal and everyone has a unique contribution to make. So, before they come to class, it is already set up that way. And then when they come in, we divide the tasks and everybody gets their turn to present their work.

Fun

It also makes it fun. One of the things I tried to do was make them feel that we were playing a game. So, it is not 'I'm the authority and I want you to do it this way'. It is, rather: 'Let's play this game and agree that these are the rules.' Rules are neutral, in a sense; rules are just rules; it is not personal. It is not that I tell you how to do it. For example, the rules of our Theory Seminar, which in this case was especially set up for PhD students, stipulate that each presentation is no longer than 15 minutes, that there is discussion, that everybody participates in the discussion and that at the end there is an evaluation. And so, people become alert and alive, because they want to participate and then in the evaluation they are happy when people say: 'This was really good!' Therefore,

there is a common goal, which is understanding the theory as something that has a bearing on what they want to know. It is not just because it is something that Derrida invented, or that Kant was always right; it must serve a purpose that helps them personally, helps them to understand better their objects, which they are passionate about or they wouldn't have chosen them for this whole long process of writing a PhD thesis. Right? I didn't precipitate any miracles, you know.

Opening Up

A very important attitude thing is opening up for answers. First, the students should all have this common ground in theory, then they each have to have their own contribution, their object or corpus. But you can also get stuck in that and have an idea that this applies to that. The third step is opening up the answers. So, if I say it could also be this or that, I am trying to open that up in the hope that others will say 'oh, yes'. In my sense that is it. And that is how they learn from each other. I believe strongly in peer learning. They learn from each other. And I think that to be successful in this you must be sincere. Sincerity seems a silly moralistic concept, but there is a point to it. We play a game, but we don't play a role. The game is to do this, and we get excited

about how it works, but you don't pretend to be democratic if you don't feel it. That would be role-playing. I think that is tremendously important. On the other hand, it is very easy because if you are a teacher who thinks, you immediately see that you are incredibly privileged to be able to do this, to be allowed to do this, to have the authority or institutional permission to work with young people who are scholars, people, political agents in becoming. And you are there with them. How lucky can you be? If you believe that sincerely, it is conveyed to the students and they feel empowered. Not in these terms, but it conveys in the sense that they feel that you are their buddy and not just a mistress with a red pencil. When I get the draft chapters, I do use the red pencil indeed. At that stage, they want nothing more than constructive criticism, a willingness for which trust must have been established.

Without Intimidation

Actually, I use a normal pencil instead of a red pencil, because I want to help my students without intimidating them. I say: Now I am going to help you make your chapter better. So, I make all the remarks with a normal pencil, because I have seen the intimidation that can emanate from such comments in red, or from harsh language. I have seen the

feedback colleagues give to PhD students about their chapters; I have seen how destructive that can be. One woman went home with a nervous breakdown and took three months to recover simply from sarcastic remarks such as: 'Meaning what?!' or 'What's the point?!' When I revise the periods, commas and other little things, I am just protecting you against a committee that might be unreceptive. Not hostile, but their task is to be critical because they have to guarantee that it is good enough. It is my own pride and ambition to help the thesis to reach the required level, and protect the students against humiliation and discouragement. Stay away from my students! The committee will never be presented with anything from my students that is not good enough. The supervisor and the candidate must have exactly the same goal. Do you think I want my students to fail? Not just because they are my students; I want to protect them, but also, it would be a shameful set-back for me. I would look foolish if I handed in a dissertation and approved it and other people would say it is not good enough. That would be a humiliation for me, too. Therefore, you have to be sincere. Not just be condescending and say 'Oh, I'll protect you, I'm mommy.' No, you do it because you have the same goal.

Sincerity

It's about sincerity. Yes, it is a question of sincerity. Sincerity in the sense that if you lie to people you don't respect them. I think perhaps 'respect' is a better word. You respect people, whether they are six-year-olds or PhD candidates; if you don't show them the respect of being sincere, then you fail them. Sincerity is a matter of respect. And so, it is not a moralistic prescription; it is just respecting other people, which is a ground rule as a foundation of society. Another human being deserves respect. Even if they are not so smart or if they don't see it, you still have to respect them. We all have our little moments when we tell a white lie, but lying to people in a situation where they are learning from the communication with the teacher, and the teacher is learning too, in that situation you cannot lie.

Teaching Generously

Teaching has to be generous. Usually, you know that you have a body of knowledge that the student needs to learn; they don't have it yet. You have it and they don't. You convey it to them bit by bit. Now that's fine, but it's not fine to think that the body of knowledge comes without doubts, that it is certain, complete, and that they need to swallow it wholesale. You can also say: 'I have knowledge, I have lived

longer than you.' Sure. 'That is my luck, but you will get there, too.' So, the experience I have is something I can propose to the students as something they can benefit from or not. But if you want to, here it is; I give it to you. That is why I get so totally furious when colleagues rip off students' ideas. Which happens. I won't mention names but it happens that a professor quickly publishes an idea that they got from a student's draft. Now I think that is the worst abuse. It is the worst deception because in fact you are saying 'I don't have enough ideas, I need to steal them'. I have plenty of ideas; I can be generous with them. I take students seriously. So, I receive a lot and I run with it and I come back and say 'how about we do it this way?' That is the result of collective work, not just of my own previous knowledge. Therefore I have total contempt for colleagues who steal from students, because I think that is evidence that they are not smart, that they don't have enough ideas of their own.

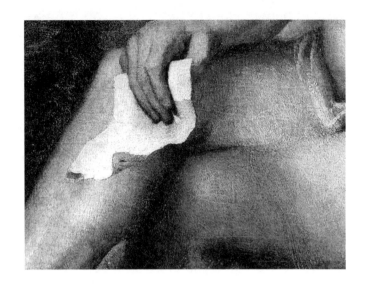

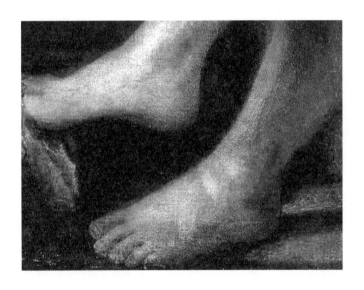

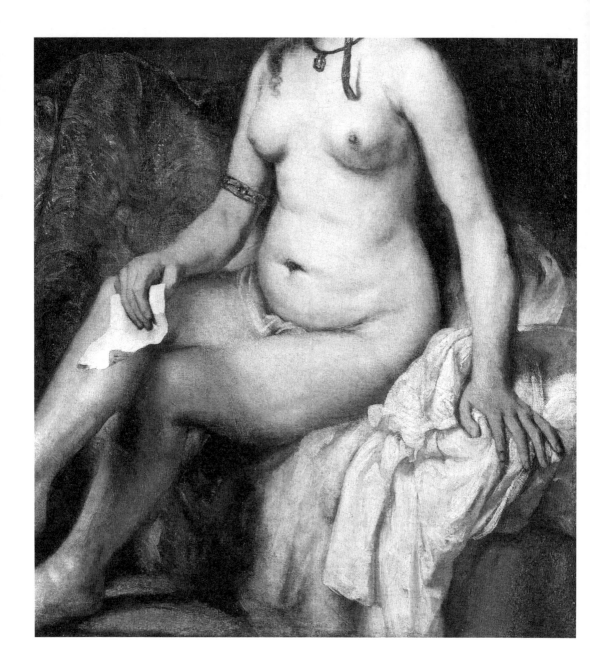

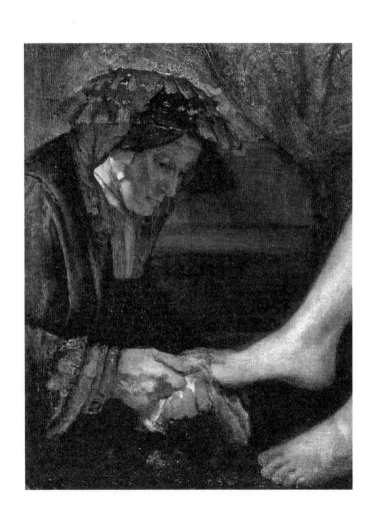

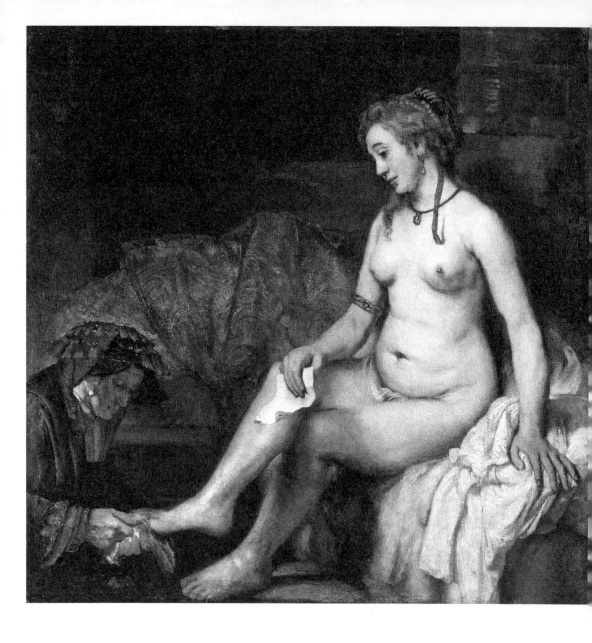

Rembrandt, *Bathsheba at her Bath*, 1654, oil on canvas, 798 × 800, Paris, Musée du Louvre.

Narratology

A Mode of Expression

Narrativity in teaching is a practice. I think we should pay more attention to that aspect because it happens, and how it happens has a bearing on the success of the teacher. So, look more closely at how the objects tell their stories. If you think of it as a practice it's much easier to grasp.

Teaching in the present
Focalization is my central concept. It is an act in the present. It is an act performed in the present tense. So, those boys looking at the witch, or what they think is a witch, in that moment, that is their moment, that is their present. The great thing about that is that in the present you can still change your attitude. In the past you cannot. Therefore, if the whole story is written in the past tense you forget

that they are actually in this moment, capable of changing their opinion, and in the way I have recalled the story they do. However, focalization is also multiple.

Multiple Perspectives

The present consists of multiple perspectives. Can I show you an image? Rembrandt's *Bathsheba at Her Bath*. We see that she crosses her legs. Now, try to do this. Try to cross your legs and put your feet the way she does. You can't do it! Because the foot is on the far side of her knee while the calf is on this side of her knee. This is physically impossible. Now, what does that mean? It is generally assumed to mean—if people notice it at all—that Rembrandt made a mistake, or a later copyist made a mistake, or whatever. No, Rembrandt was no sloppy painter. In my view, Rembrandt is making a point about narrative. The spectator looks from the front and sees a nude, really a nude. She is a bit shy so she looks sideways, but it is a nude. You get to see her body and you can think, hum, I wish I had that body at my disposal. Which is exactly what the other, barely visible character in the story, King David, is thinking. He is another focalizer. But there is also this other woman who is a servant, and who is cleaning Bathsheba's foot—that foot that is logically in the

wrong place. Making her ready. In fact, she is making her ready for royal rape. King David is about to rape Bathsheba. And so, this is a bad story, a story of abuse. But how can you make a story of abuse so that the spectators get it in their present, not to imitate the abuse but to reflect on it? So, what Rembrandt did with the foot that doesn't match, the foot that is on the wrong side, is not a mistake. Imagine he is making a collage of two paintings. One is the nude that entices people to desire her. The other is the narrative—which is in the direction from her to the servant and the guy who is spying from the roof—this is what the story is going to tell. It is going to end badly because she is going to be prepared like this, to be taken to the king to be raped. What she has in her hand is a letter. That letter has no direct bearing on the story, other than being an allusion to the letter that the king has sent to the head of the army to say 'put her husband in the line of danger'. In the biblical story Bathsheba never sees that letter. But, with the crumpled letter and the melancholy look, she is already in a sort of subjection and acceptance that her life is going to change. Her husband is going to die and she is going to be taken by the king. It is a completely different story from the one we see at first sight, of a nude woman presented for your pleasure, but one that you, as the spectator who lives in the present and sees this nude

body and can have appreciative responses to it, are also compelled to acknowledge, at least if you really look at her and recognize the oddity. Then you notice that, because of the foot directed to the left and behind where it should be, she is not there for you. Then you can come to the conclusion that she is basically in that nasty narrative. So, there are two stories in the painting, two 'takes' if you see it as a film: one take from the front and one take from this side, in a montage that combines them. That tells you that there are multiple focalizing positions.

Awareness

It is up to you whether you want to abuse Bathsheba, appropriate her, exploit her, or protect her against the danger that is about to happen. You are made aware, you can even 'feel' it, that there are not one but at least two images, two stories; two genres even. It is also a play on the genre of narrative. That is, for a smart artist like Rembrandt, you can assume he must have had his tongue in his cheek. For the teacher, the question is, how do you get students to be sensitized to this? I do it a lot in the Louvre where this painting hangs. I stand there and I see people look, and when I see them slightly puzzled, I often say: 'Have you tried to do this; cross your legs and put your foot on the other side?' Oh, blast yes! That is

difficult, you can't do that. No, you cannot, and we start to talk. I do this a lot because I find it so funny; I see people become confused. I think that on an unconscious level or maybe even on a conscious level, they think Rembrandt made a mistake. Well, he was a good painter, so don't worry. Rembrandt doesn't make mistakes. Not of such magnitude. Do you see this woman? What would be her position if she wasn't directed in your direction, her body more compatible with her gaze? My book *Reading Rembrandt*, in which I develop such arguments, invariably taking the act of serious, engaged looking as their starting point, was criticized in the Netherlands, but much more positively received in the United States. My view of Rembrandt was a construction in the present of looking. An anachronism if you like, but one we always necessarily 'commit' when writing on art, because looking can only occur in the present. Working with this concept is taking yourself seriously and taking responsibility for your interpretations, the narratives you construct.

Acting

Spectatorship is an act; it is not a passive situation. Basically, you are in the middle of things. This is the title of the book I just published: *In Medias Res*. 'In medias res' means in the middle of things. The

subtitle is: *Inside Nalini Malani's Shadow Plays*. And that is your inside. The whole argument of this book is that you are inside the world the work creates. In the beginning of that book you see a child who is maybe five years old, who is inside the exhibition space; she is standing underneath the rotating cylinders and she spends half an hour there. Why would a child want to spend half an hour inside a room where there is an artwork with an accompanying soundtrack? You see these figures, the animals and the boxers and the dogs go by. So, they come alive, in a sense, but you also see how they see each other because the arbitrariness of the turns creates completely different stories all the time. Sometimes you see a Byzantine angel clashing with a colonizer with a gun. But he never gets to kill the angel because the angel is already on the other side of the cylinder. And that is the fun but also the deep meaning of this artwork. It is fabulous because it is figurative but it is also not logical.

Social Moment

Such an experience is a social moment. The important thing is that it establishes a relationship, a positive relationship with the artwork, with each other, the peers, with the teacher; because you have this enjoyment together. That is what's important. I think

fun, humour, joy are social moments that you feel intensely. But if you have that experience together, you are in a relationship and that is good for the social fabric, for the fabric of the social world. Therefore, I think such an experience is very important; it de-intimidates. It de-intimidates because we are always a bit in awe of artworks, like 'oh god, this great artist, this master', a *he* mostly, did something that I cannot do. But if you have this kind of joy of getting it, or relating to it, standing there in the middle, then you are part of it and therefore it de-intimidates. You are no longer intimidated. This is for us all. It is part of our common legacy. For an artist who exhibits or sells work to a public institution is giving it to us. Focalization allows you to step in: it enables you. That is a better word. It enables you to step in so that you can be part of what gives joy. I hate to say the word 'share' because it is currently so revoltingly abused, but what you have is simultaneous participation with others and the artwork, so you are there together.

Make 'Speak-able'

The concepts that I offer in *Narratology* serve to make speak-able, discussable, what each person contributes when they say how they read. It is that thing again about everyone being different and everyone

being in a sense unique, but able to communicate. I am opposed to rigid, fixed theories. Some narratologists do research with cognitive concepts and they say: 'This is what happens in your brain when you read.' Either it is completely banal, like when you take words and make a sentence, or it is completely wrong. It is bossing you around and telling you how to read, in fact. It becomes prescriptive, because if you don't do it as the cognitive narratologist thinks it should be done, there is something wrong with you. Instead, I develop concepts not to prescribe or automatize an interpretation, but to make the various interpretations, in their differences, discussable.

No Categories

Categorizing is madness. The problem with all forms of typology is that it is not just bossing the reader around, but bossing the text around. It is telling the text where it belongs. This is where I came from when I started this work, and this is why my ten-year-old guinea pig was doing better than the students in the teacher training college. Because those students already had some notions from secondary school of these typologies, which hampered them, like the classification into authorial narrative, personal narrative and neutral narrative. Now, neutral doesn't exist; we agree on that, I suppose. This

insight makes it necessary to see the difference between authorial meaning, as if you see the narrator and the narrator tells you some things, on the one hand, and personal meaning, perhaps plural and conflicted, which comes from the focalization of characters, on the other. Most stories have a mix of these two. So, an image or text that shows such a mix becomes a hybrid of two of such types, and that is quite correct because it doesn't fit the box. But how can the most common, standard mode of narrative be a hybrid, an exception to the rules of the classification? That is the problem with typology: the texts are made to fit into boxes, which is not the same as understanding. This is what we have to make clear in this book; that categorizing is not understanding, but boxing-in. Categorizing is labelling. It is the mad assumption that everything has to be categorized. This also underlies racial type-casting, you know, all those problematic theories we cast in the nineteenth century but still live by. Sorry, but we are in the twenty-first century and we should be wiser than that. We should have learned what happens when you categorize people. Now, don't do to artworks what you don't want to do to people. It is stopping, it is avoiding, it is limiting. I always say 'don't use concepts as labels'. When we categorize, all we do is say this is this and we can move on, without bothering with the details of the artwork.

No, maybe this is this, maybe a bit, maybe not, maybe not entirely. But then what? What is the purpose of such characterizations?

De-categorizing

Let's call it de-categorizing. De-boxing is nice but then people might think it is about the sport of boxing. But the point of my critique of typology is that it is not conducive to analysis; it just puts things somewhere. In contemporary visual art, I have so often encountered the problem. There are always oppositions; as soon as there are binary oppositions, I am out of there. The opposition between abstraction and figuration, for example; the result of that fanatic opposition is that, first of all, people don't dare say anything about abstract art, because you can't tell stories with it, you don't narrativize. But the binary opposition also entails a linear, chronological view of history: figuration is conservative, old and obsolete; truly modern art must be abstract, otherwise the work is conservative. All the post-classical figurative painters are considered bad painters now. As if you can say: Marlene Dumas, terrible, that is really terrible painting, right? I give this example because Dumas is actually my favourite painter. And I'm now working on Munch, and oh god. I have just mentioned two of the greatest painters who have been

considered not quite progressive enough. But you can simply reply that their work is precisely undermining that opposition because they use abstract modes of painting to create something in which the figuration functions with more subtlety, for example. Then you have a completely different set of concepts and you have to accept that the world cannot be reduced to a set of binary oppositions.

Allusions

Instead of categories, I prefer to use metaphors or, even better, allusions. Metaphors are different from categories. Metaphor is saying: you think you see this but, hey, look again and think about what it may mean. But the danger of metaphor is that it becomes a substitution and then you get this: a bouquet of flowers with some flies on it is no longer a bouquet of flowers, it is a *memento mori,* because the flies stand for corruption and decay. Then the whole bouquet is no longer a bouquet; what you see is not what you see. But no, it is a bouquet that *also* contains little allusions to decay. Then this is an image, one which brings in a temporal aspect that is challenging, hence activating, when you think about time and visual art. I am actually more and more pleading not so much for metaphor as substitution, but as allusion. It is this, but it is also alluding to

that. Sometimes predictively, for example when there are details that go in some other, narratively future direction, but still stay what they are. Because otherwise you are de-visualizing. I have nothing against the concept of metaphor, but the risk of that concept is that it puts one thing instead of another and if you say it is both, it is actually a comparison.

Narratives

We all use narratives in teaching. You come to class on Monday morning and ask: How was your weekend? You are asking for narratives. That doesn't mean that this should become the tool that we use all the time to get students to speak. They do it in nursery and primary school. 'What did you do this weekend?' And then the kids talk and tell stories. 'I went with my dad to this and that.' That is no big deal, there is no great importance attached to that in itself, it is just a way people are enabled to communicate something that is in their own world, in their past, and that comes into the group in the present. In that sense, you can talk about it: 'How did you like it; where did you go in Amsterdam, which museum did you see, which departments of the museum?' Then they start to talk. You are already in narrative but it doesn't have any surplus value to call it that. I just say it is a frequently used mode of

expression and I think it is important to realize that and study it, because that is what we do and because it always gives a certain slant, a certain vision of the events that you tell; of course there is focalization again. That is why I find it important.

Mode of Expression

Narrativity is a mode of expression. The point is not to say: 'How can we stimulate narrative?', because narrative is unavoidable; people do it, they tell stories anyway. What can you do with it? What you can do with it is to point out the underlying selections and ask: 'When did you see what, and how did you see it and why did you find it exciting or disappointing?' How can you use that as a tool? You cannot. Right? You cannot take everything as a tool. Narrativity is a mode of expression. Within that, you can find tools to unpack it, to analyse it, to make it specific, within that; but not the thing as such, because it is banal. It is totally nothing. There is no border. What you can do is think about what it means to use narrative instead of drama or poetry or argumentation; modes we also use. But then you take bits from that insight and you can use that in teaching, but not as belonging to a category. The more general a term or concept is, the less useful it is. Narrative does not exist. A mode of expression is practiced, but it is not a

thing. If you say it exists, then you are still not saying anything. What is narrative? It is nothing; it is completely air if you don't bring it to bear on actual practices. So, instead of going straight from narrative to teaching, you are better off, you have more chance of success, if you say: 'What does (this) narrative consist of?' And even that is the wrong question. How is the practice of narrative conducted?

Practice

Narrativity in teaching is a practice. And I think we should pay more attention to that aspect because it happens, and how it happens has a bearing on the success of the teacher. So, look more closely at how the students tell their stories. If you think of it as a practice, it is much easier to grasp. I can see a painting or a sculpture as an object and what you do with it is a practice. If you are going to engage with it, you try to turn it into a subject, but that is for another day. A painter painting is a practice, but that is not the practice I'm talking about. I am talking about the practice of teaching—because we were talking about teaching—and the way narrativity is part of that practice. I think that is what you want to get a handle on, and not make it general, banal or rigid, because then you box it in. Look, then, at what the role of that narrative is; how it plays out in practice.

Examples

Steven Spielberg's film *Schindler's List* is a fabulous example of how we can use narratives in teaching. It is a film that was intuitively criticized, immediately. 'Oh, it's not true, that is not how it was, it is banal, I don't know what is wrong with it; everything.' If you analyse it narratologically, however, it becomes much more interesting and complex, and you get many more moments for reflection than for judging. And then it becomes a much more powerful film. Personally, I don't like the ending; I think it is sentimental, the stones being put on the grave. But I appreciate the film as a whole. I always defend it. Intuitively, if only because my son came out of the cinema weeping like a red-eyed child when he saw it. How long ago was this? 20 years? He's now 50, so he was 30 then and he had no idea that these horrors had happened. Now, you cannot imagine that you have no idea. But the whole education about the Holocaust had petered out at a certain point and it stopped, before it was taken up again. Spielberg comes in and he does it again. My son didn't know a thing, or what he knew he knew as distant history, and he was completely upset. Useful.

Thought-provoking

In that film, the constant change of perspectives is very useful because it is thought-provoking. The good guy and the bad guy look alike. The Schindler and Göth characters look alike. Which makes you realize that the same people could do this, or the opposite. I think also that the film avoids the pornographic effect so easily provoked when violence and suffering are graphically represented. You see that the victims are naked, turning around and going to die, but you don't get a chance to focus on the naked bodies because the image is blurred and moves too fast. You don't really get to see it. You can't do this number that you can do with Bathsheba and say 'oh yum'. It sounds too horrible to be plausible, but yes, voyeurism can feed, stimulate, even produce sadism. So Spielberg's is a good visual strategy. It also shows how difficult it is to exist, how precarious life is. The film probably idealized what Schindler did, but still, it is not about Schindler the hero; it is about what you can do to resist terror. I think there are all sorts of ways in which this film is poetic: the arrival of the train, and the unexpected effort to give water to the people in the train. It has been a long time since I have seen it, but I do think it is an important film, socially and educationally, for the generation that does not automatically know these things. We overestimate what people know of the past. I think for

this reason that film is important, including its accessibility. There is always the notion that history is so important because we should not forget, so that we don't repeat. In that perspective, *Schindler's List* teaches us a lesson. How not to forget? By making my son cry.

Political

The practice of teaching is also political. Power is involved. I started with the example of the boys looking at the witch. Is that political? You begin by thinking, someone is a witch simply because she is a woman living alone and she is old and you end up realizing: No, she is afraid of us. 'Political' does not mean voting for either a left-wing or right-wing party. It is not party politics we need in education. What I call 'the political' is the social fabric of how people think and talk to each other about things, as political scientist Chantal Mouffe explains it. Power is involved. Focalization is a form of power. It is not expressed, it is not said, it is not saying 'now they know the truth', because there is no absolute truth. But the fact that the three boys together are able to look through the window and see this woman alone, that is already a power inequality, for they can run away; she cannot, because she is old. They are three, she is alone. There is a complete power

discrepancy, which you don't see if you don't see the focalizing structure. And to avoid having to recognize that you are on the one end of that power discrepancy, you can think: 'This woman, she is a witch, so she has power. She can turn us into geese and do really horrible things.' The frequent use of narrative is a constant interweaving of visions, views and opinions. In this respect, a story is more influential than saying 'I think', because then the other can say 'I don't agree'. But if you just show an image, you are also saying 'I think', but you don't say that out loud, you probably don't even realize it; you see it and assume that seeing is the truth. To de-naturalize the truthfulness of seeing, you should understand that power relations are involved; I think that is intervening in what is political. Narratology is a political tool as much as an artistic one.

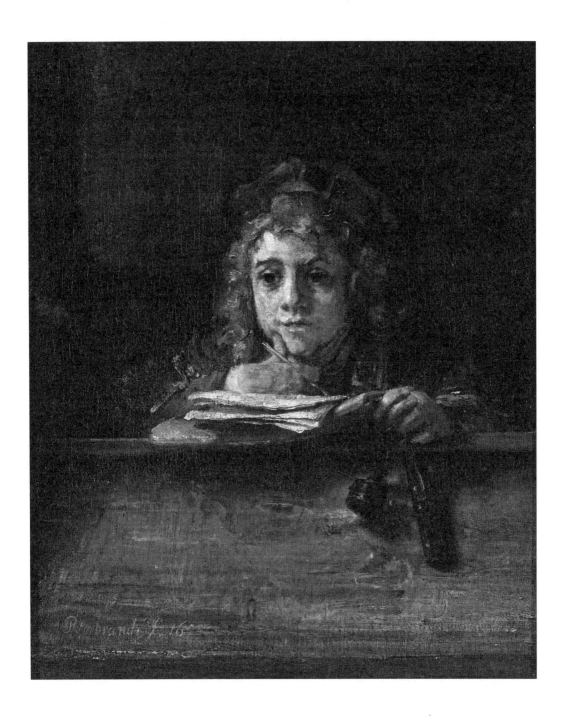

Rembrandt, *Titus at his Desk*, 1655, oil on canvas, 177 × 63 cm, Rotterdam, Museum Boijmans Van Beuningen, photograph: Studio Tromp.

Close Reading

A Methodology of Openness

It is the change, the change in perspective in seeing, that is important. It means that you learn to be always able to find new things. Therefore, the learning is on multiple levels: you learn about this one detail; you learn about your own need to get rid of your presuppositions; and you learn about finding new possibilities. That is a very exciting and exhilarating experience, finding the possibility to see something new. With that, you learn a methodology of openness.

Learning Versus Teaching

Rembrandt's painting of Titus at his desk is instructive because what you see here is not teaching but learning. This boy is totally absorbed in thinking. If you look at Titus' eyes, his face: this hand on his cheek forms a gesture that you make when you are thinking. A catalogue image is, of course, nothing compared to seeing the real thing. The interesting ambiguity is that he is putting pen to paper and at

the same time he is not. So he is interrupting his writing to think. There must have been an inner dialogue between what he thinks he knows—he is about to write it—and thinking, wondering: Am I right to think that? Therefore, the painting is the perfect image of what I mean, what students need to learn. There is astonishment also; the eyes are a bit interiorized but also as if astonished. I am totally impressed by this painting now that we are talking about it. It is the perfect image of what it means to learn. He was writing and then he said to himself: 'Wait a minute'. I never studied this image until you put me on the spot just now.

Pregnant Moment

That is the perfect moment of learning. In painting, which is a still image, the artist making narrative images is often looking for what they call the 'pregnant' moment, the moment that something changes or is about to change, catching the figure right between the old situation and the new situation. That is the moment. It is instructive to try to define what that moment is, what changes into what. What the artist catches here is how the boy who was writing exercises at this moment is escaping the routine by means of thinking. Of course, we don't know what he thinks; maybe he is thinking 'What bullshit

is this that I have to do these exercises?' or maybe he is thinking of something else. No matter; he is not real, he is 'only' an image. The point is that this is a moment between two moments. Given the subject of the painting, we can see it as the moment between conducting mechanical learning and deep learning, understanding. So, writing the rules is very important, otherwise you cannot do what you need to do, but it is not enough, says the painting, in my view, and in the context of our conversation. This is the same Rembrandt who made the 'mistake' with the feet ... Come on! No, this is a really profound picture. People visiting museums, if they look at the paintings at all, instead of just through their phones, say things like: 'Oh, how cute, he must love this boy.' Nope, that is totally secondary. Or maybe you could say, out of love he respects him and he puts him down as a philosopher. That is a way of saying that this child is a person with depth; and he is learning something radically, deeply important for the rest of his life. Hence these big eyes that are interiorized and astonished at the same time. Now, it is unlikely that the boy was looking like this, because posing means hours and hours of sitting, which is another routine explanation. He cannot be having this experience all the time. Rembrandt projects onto him, but that doesn't matter. That is how the artwork 'thinks', offers food for thought, rather than the boy.

Facilitating Learning

Teaching is a means to help to facilitate learning; you have to help and not hinder the learning. Titus is not in a resistance mode but nor is he the recipient of teaching. Teachers often think that children have to receive their teaching; no, the teaching has to happen on the spot between the teacher and the student who is then learning, and the teacher just as much. This is not always clear to teachers, because teachers are sometimes so arrogant that they think they have nothing to learn. But of course, they are constantly learning. The moment they stop learning... they die. Life consists of learning.

Teaching in Dialogue

Teaching is a dialogue. The students or pupils can enter into the work on their own terms: hence, the work is in dialogue with the student, instead of the student being subjected to a great sweeping statement. If you show a detail it is incontestable; you can interpret it in different ways, but it is incontestable that it is there. So, you cannot overrule the work; that's what I mean when I say that the work is speaking back. First of all, you make a more detailed interpretation and anchor that in the text or image. This is a matter of respecting not only the students but also the artwork. We talked about that last time,

that the students deserve respect and that you cannot overrule them with intimidating high theory without giving them tools to work with. And the same is true for the artworks; respecting them requires their close reading.

Against Intimidation

Dialogue and intimidation contradict each other. If the teacher gives the student a text and the student doesn't know what to do with it, that is again a form of intimidation. Then the teacher can say: this really means this, period. But if you say instead, let's read this, and you go through it, asking, for example, what does it mean that this line of the verse goes over into the next? I am just thinking now of that example of an *enjambement*. Enjambement is when a verse is rhythmically finished, while the sentence or phrase does not stop at the end of the verse but continues in the next. That means that there is a little stop, but because the grammar takes you over into the next verse, the stop is smaller, shorter. Now, that can mean something. There is a poem, I think it is Verlaine's *Chanson d'automne*, where the verse before last ends on *la*, the article, and the next and last verse begins with *feuille morte*. The reason this is important is that after *la* there is a little break.

CHANSON D'AUTOMNE

Les sanglots longs
Des violons
De l'automne
Blessent mon cœur
D'une langueur
Monotone.

Tout suffocant
Et blême, quand
Sonne l'heure,
Je me souviens
Des jours anciens
Et je pleure

Et je m'en vais
Au vent mauvais
Qui m'emporte
Deçà, delà,
Pareil à la
Feuille morte.

—Paul Verlaine
(from: *Poèmes saturniens*, 1866)

What does or can this mean? Perhaps that the break corresponds with the break that makes the dead leaf fall down. Now that is a beautiful poetic device. The importance is that the poem shows you, physically if

you read the verses out loud—and only a poem can do that in language—what it means to break off and fall. That is something that all students when they read it may feel, but they don't quite realize. Then the teacher takes them through the entire process of reading with the body: What does it mean, the end of the verse that is not really an end? Then they get it, and can turn their unreflected experience into an idea. The verse fails to stop, but still, there is a slight break. Similarly, the leaf that falls is not really the end, because new leaves will come. This is just one example of how a detail matters. We have seen a much more spectacular one in Rembrandt's *Bathsheba*.

Subtleties

Here is another poetic one: *Il pleure dans mon coeur comme il pleut sur la ville* (Paul Verlaine, *Romances sans paroles*). This is not an enjambement, but an a-grammatical formulation. It is not correct grammar to use the impersonal for a verb such as *pleurer,* which is personal. *Il pleure* is made analogous to *il pleut,* which is an impersonal construction, since 'to rain' cannot have a personal subject. It is raining. It rains. So, the lyrical subject says: 'It cries in my heart, as it rains on the city.' He is expressing grief or a depressive state in words that say that he doesn't do

it, he cannot help it, it happens to him. He expresses that nuance by an analogy with another expression that is grammatical. He makes an a-grammatical construction and then makes it more or less grammatical through a grammatical parallelism between his heart and the rain. Now, you see the rain and it is sad, you have a sense of greyness and the desire to flee, and that is what happens in his heart. There are no more subtle ways to express something like sadness without referring to the melodramatic events that caused it. It is just a state. *Il pleure*: you can't say that. When you say *il pleure* you assume there is a boy who is crying, but *il pleut dans mon coeur* turns crying into an absolute sense, into an impersonal sense; something the subject cannot help. That is a detail that is entirely impossible in everyday language, but in poetry you can do it. Now, I am using these two examples from French because that is what I studied first, to show you that it is not difficult: both these examples are easy enough. There are no sophisticated words, no difficult constructions; just ordinary French. I think the importance of this is that the students can easily understand it, because there is no particular difficulty and yet it is highly sophisticated and subtle, so they also get a sense of the level of subtlety in poetry that you don't acquire so easily by learning by heart the rhyme schemes and the figures of speech and all those things I had to

learn in high school. You need those tools, but having them doesn't help you if you don't go to the text and pick up the details. Therefore, it's again a democratic issue.

Listening

I think it is important, maybe the most important thing in teaching, to listen to the poetry of a text, as important as in visual analysis it is to look. The most vital thing about teaching and learning alike is to unlearn everything you already know. This is necessary because when you go to a text or an image with pre-established knowledge, you are going to see what you expect you are going to see, but that is not necessarily what is there. The close reading helps you to be thrown out of your preconceived story, and if it comes up in your mind you have to say: Well, this is just not what I am seeing. To be able to see, instead of seeing what you already know, you have to have to open your mind, but you also need to put all your knowledge to sleep. Even the greatest art historians tend to approach artworks armed with previous knowledge. For example, the chief of the Rembrandt Research Project comes to Rembrandt's painting of Samson already knowing that Delilah is a bad woman. Therefore, he cannot see that she is actually depicted as a motherly and frightened figure. He

cannot see it because he 'knows' that she is bad. Now, how does he know that? Not because he has studied so much of Rembrandt's work, but because he has grown up with the misogynistic stories. In primary school, we are taught that Delilah is bad (and by extension all women, but that is another story). I have caught him out on descriptive moments where he is just wrong. If you teach children to look, they can also see that he is wrong. That judgment on Delilah, and by extension 'women', is not true. So, close reading is about seeing details, but it is also about unlearning, let's say suspending the bigger picture that you think you know, which is called ideology.

Voyage

The work and the joy, the pleasure is in the voyage through the work. I have nothing against theory, but models can become restrictive. I think that, as much as the students need to unlearn what they know, they also should rid themselves of the desire to come up with a concluding, coherent interpretation. When you are finished with your reading, of course you go home with something in your mind, with an impression. It can be an interpretation but it is never closed, and that is the difference with many of the models, like the structuralist model.

We have learned this sort of structuralist analysis, and the model can help there. But if we simply 'apply' such a model, all it does is make an abstract picture of different steps in a story. Stories usually start with a hero going out on an adventure, there is a challenge, there are some difficulties and in the end, he gets the bride. Now, what kind of story is it? Why would that be interesting to know? What is interesting to know is what does not fit, that which goes against such an overall reading and makes the story complex and difficult. The usefulness of generalizing models is to set off the specificity of the particular story you are studying, not to confirm a generalization.

Experience

Learning is something you do by experience. My favourite example, which is always successful, in the book on Rembrandt is Bathsheba. I have already talked about the impossible position of the feet. I was in Madrid for the launch of my book *Tiempos trastornados*. One of the respondents was the director of the Thyssen-Bornemisza Museum, which is a great museum of world-wide reknown. I thought this man was going to be like so many other museum directors, not really interested, except in budgets, but he had read the book from A to Z. He had

profound questions and he came up with this Bathsheba, and he started to do it: to attempt to imitate the position of the figure's feet. He was sitting there in front of all these people in a large auditorium and he said 'you pointed out that...', almost fell over, and really got excited. He said that this was a learning experience. That was an incredible experience, for the audience to see that a prestigious man in a business suit was doing those acrobatics on stage to explore what a painting was doing. This is also what I mean when I say you can point it out. Try it! Just by doing, by experiencing, things change.

Change in Perspective

It is the change, the change in perspective in seeing, that is important. It means that you learn to be always able to find new things. Therefore, the learning is on multiple levels: you learn about this one detail; you learn about your own need to get rid of your presuppositions; and you learn about finding new possibilities. That is a very exciting, even exhilarating experience: acquiring the capacity to see something new by learning a methodology of openness. It is the dialogue with the work that I always insist on. In this situation, it is really possible to say that the object speaks back; it is possible to say that there is a dialogue between two subjects, not a

subject/object subordination. So, all these different layers of learning come together in the simplest thing, which is to look at details, taking form and meaning as mutually supportive, even unified. And that is close reading. When this term was first developed it meant that the text speaks for itself. This implies that if you are smart enough to hear the text speak, you understand it. No, the text does not speak for itself; neither do any of us ever speak alone. We speak *to* someone, whether or not there is an interlocutor present. And we do it in a way that resonates with the expectation you have of what that person wants you to say. In a dialogue we discuss, and like now, I'm explaining something because I know you want me to explain it. I would not do this to people who don't want that because then we talk about different things. Sometimes you are a little intimidated or you feel inadequate. There are always responses to the second person built into what you are saying; therefore there is no monologue.

Invitation

The object also invites you, by being beautiful, by being enigmatic, sometimes by being outrageous. The object invites you and you invite the object; that is the dialogical nature of communication or speaking. But it is communication; it is not objectification

or reification. That is why art is important and that is why it is worth teaching. It is culturally crucial, I think, that students learn this. You can also invite a student to see things. Everybody has a sense for detail. You see something and lead the students to seeing that too, but not immediately saying why it is there or this is what it means. Rather, you say: 'What do you think? What can you do with this? What could it possibly mean?' While respecting what they say. Then, in the discussions, the students are going to contradict each other and argue. You come out enriched.

Teaching Objects

Objects we pay close attention to are in fact teaching objects. It is not only the viewer who is looking at the object, but the object is also looking back. The object even teaches. It teaches if you care to learn from it. I described this experience earlier with the poems *Chanson d'automne* and *Il pleure dans mon coeur comme il pleut sur la ville*. When you read those poems carefully, with attention to the cadence and the verses, the grammar and the unusual construction, you learn something. Among the things you learn is the freedom the poet took with the rules of language and versification. That is useful to learn regardless of the specific detail within the poem. If

you did learn something, then the object was teaching it. I mean that learning and teaching are in a dialogical relation about the same object, between the one who knows more than the other and is trying to make the other experience that same excitement about learning. If the object does that, then it teaches. But the object that looks at you doesn't even have to look back. It is just looking. It is the experience that you have of the object being alive and having something like a mind of its own.

Lacan said this famously about a sardine can; in his little anecdote, the sardine can looks back at you. What he meant to say was that the world—this is the whole theory of the gaze—the world makes us by framing and shaping us, and we are part of the world; this is framing in the positive sense. The world makes certain things possible to see, visible in the literal sense, and other things not. Part of that are all our routines, everything you think you learned and you think you know. But the object that looks back is in a sense abducting or adjusting your gaze to go in a certain direction that you have not yet directed it to, that you were not going to use. It is basically the same idea as that the object looks back. Here, the whole framing, the whole world allows what and how you see. The gaze in this sense is like language. You need to know the language in order to be able to use it. Similarly, you need to know the

visual language to be able to see; you need to know how to look. But like Verlaine, you can also shake up the limits the rules impose. Part of that can be learned, part of that you have in you as a person because you have a personality. You look at it in a certain way, but it is not entirely subjective. This is the difference with phenomenology. It is not just the subject who decides, because the object is also in a sense alive, and thus becomes a subject in its own right. Although it does not really have a mind, it does have cognition.

Agency

The objects have a kind of agency. I cannot define it precisely, but an object that makes you feel different than before has agency, and that goes toward saying it has cognition. Agency is a form of directing, but not with an intention; an object doesn't have intentionality. All these concepts are to distinguish humans from things. But what if we gave up on that hard distinction that says: 'Humans have a really good deal, they can think and do a lot, but things cannot.' The distinction is more fluid and relative. Things can do more than we think they can. We tend to assume that the object is dead so that we can feel superior and alive, but it is much more fun to go in the opposite direction and say that the object is

also alive, so that you can encounter it. Then, we can talk; that is much more exciting than to subject it to some preconceived idea. A dead object makes you feel abject; I think that happens if you don't accept its aliveness. If you resist the agency of the object, it is going to make you uncomfortable.

Complications

Looking at objects can also give some complications. The boy in the Rembrandt picture doesn't look at you. That complicates your senses. You cannot easily say: 'Hello boy, it's nice to see you.' You cannot do that with this image, and yet he is directing his look towards us. So that is a distinction to make: directionality as different from engagement. He is not engaging us because he is too busy thinking. But he is directing his gaze towards us, as if inviting us to also do some thinking. That is another way you can see it. This makes his eyes more important rather than less for not being addressed at you. That is the beauty of this work. Every time I look at it, with everything I say about it, something comes to mind. Don't think that I knew this; it just occurs to me as I go along. It happens when I look. I have really never studied this theme. So for me it is totally new. But precisely that makes it possible to not say, the painter loved his son, but to say what is

happening here and now. Then in the end you can say: He must have loved his son to make him so philosophical. But if you start with 'he loved his son', then you don't get beyond the cute cheeks and beautiful big eyes.

Teaching Without Separation

We need to unlearn the separation between intellect and emotion. We have been told these are very different, the former more worthy, more reliable than the latter. In consequence, we were taught: don't be emotional but rather be rational. I think close reading is an act that ignores the distinction between intellectual, sensitive and sensuous responding; that is another reason why it is so important. The senses help. Do you know who said that? The same Descartes who is accused of having promoted the separation. He said that the senses participate in intelligence, in the intellect and in understanding. Understanding is intellectual plus fantasy, imagination plus dreams and the senses. Descartes said that they all contribute to understanding. I don't remember where I got this when I was studying his work for the film I wanted to make, but I didn't make it up. And Spinoza, of course. I think I am in line with these two when I say to my students: I am passionately rational.

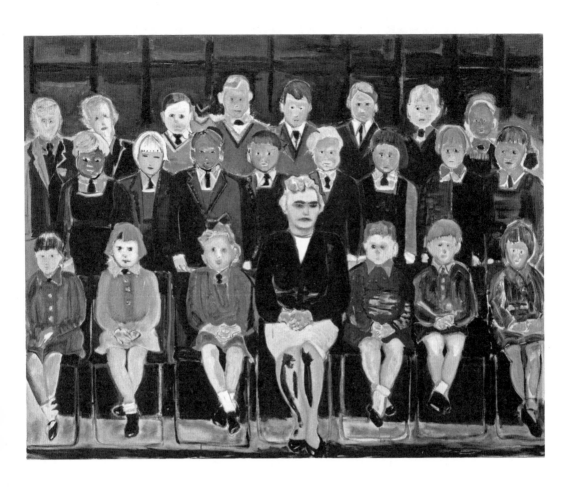

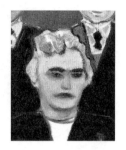

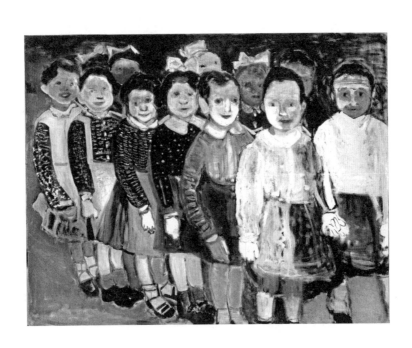

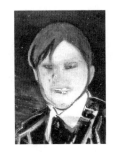
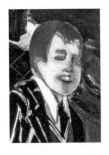
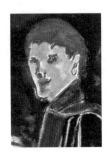

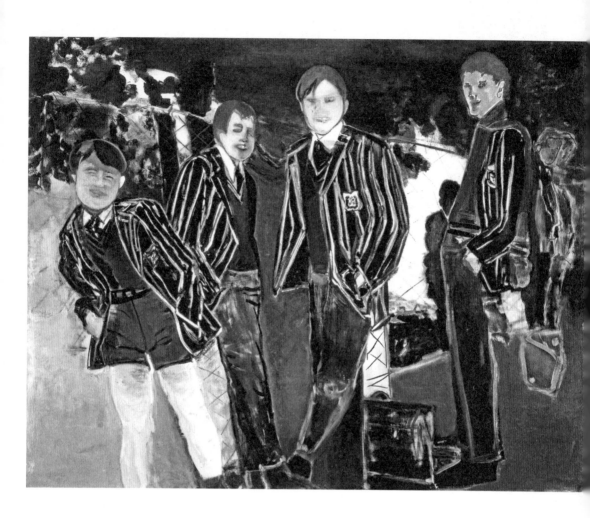

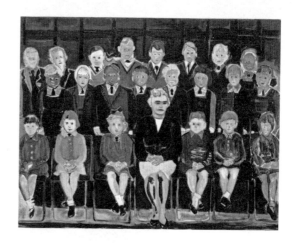

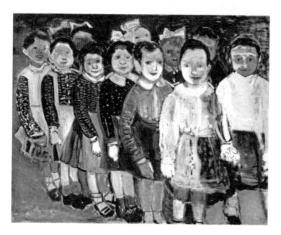

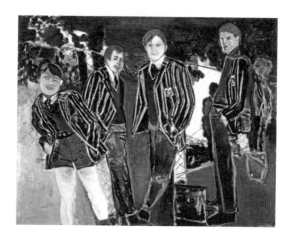

Marlene Dumas, *The Teacher*, 1987, oil on canvas, 160 × 200 cm, private collection.

Marlene Dumas, *The Turkish School Girls*, 1986, oil on canvas, 160 × 200 cm, Stedelijk Museum Amsterdam.

Marlene Dumas, *The Schoolboys*, 1987, oil on canvas, 160 × 200 cm, private collection.

All three paintings, photograph: Peter Cox.

An Approach to Doing

If people are coming to you with the expectation that a method is a method and that you need methods, I wouldn't pick that fight. Perhaps I would say 'I don't have rules for this method; it is a practice'. Call it a practice and say how you do it; then others can see if they want to do it the same way.

Posing

Of these three painting by Marlene Dumas I love *The Teacher* in particular. It is not a classroom because they are posing for the school photographer. This is not a teaching situation. They are posing for the group photo. Those photos are taken every year, in my childhood too, so that we would have a memory of the whole class. Although it is a class, it is not a classroom in action. There is something really eerie about it, which is often the case with Dumas. The

teacher is not quite looking; she is looking a little bit sideways, not straight ahead like the pupils. This expresses a kind of indifference: as if she is sitting there because she has to, but she is not really engaged, while all the children are. The eyes are amazing. Some look frightened. But they are all looking at the photographer. Almost all of them have round eyes except that one girl, or is it not a girl? I don't know, the one who has her eyes closed, maybe just by chance. When the photo was taken she had her eyes closed; that happens. If that is the case, it is striking, because she doesn't look like the rest. There is no other explanation. Then this is the little symptom of Dumas' method of working from photography. She never paints from real life; she always paints from source photographs. She considers photos close enough to reality. As a painter, you cannot emulate reality; reality is always better. But you can paint a photograph. This is her anti-realist stance towards representation. That is why she has this revolutionary way of doing self-portraits, where she is not looking in a mirror but, for example, sideways. You can only do that if you are looking at a photograph. She has this principle and she works with it. I would say that those eyes indicate that principle. I love the way she paints.

Line Up

The Turkish Schoolgirls is another amazing painting. It is so fascinating how they are lined up to be almost in perspective, but not quite. So, it is not perspectival and it is not frontal, but something in between. The girls are in a row, they are walking; maybe you could call it cinematic. They are going away, they are moving out of the frame, but also coming closer to the viewer. But then this first girl is looking at us. This is the child that is looking at the photographer, and the second one also looks at us, and some of the others a little bit. But this one is most striking: doing that with her large dark eyes. And then there is the lovely hand-holding that you only see in this image. They are holding hands. That is the kind of detail that tells you that these are little children. There is a teacher somewhere who is very concerned for their safety; they are told to hold hands because that is a way of keeping them together. But we don't see the teacher. The bows on the hats and in their hair; it is lovely detail further specifying the kind of children they are; girls, little. It is also striking that they wear no uniform. I think in the other picture they do wear uniforms. There are no uniforms; there are just children, all wearing different clothes and shoes. They are clearly all girls and they wear skirts.

Grouping

The Schoolboys, now that is a different picture. These images have less and less to do with schools. This one is just saying 'adolescence'. They are not grouping. There is a car behind them; they are just hanging out. They are probably schoolboys who are playing truant today and are skipping class; they are loitering, outside, but they do wear uniforms. In certain countries, they wear these jackets and this is probably the insignia of the school, but they are not actually in school. They are laughing, they are mocking the idea of having to go to school. The girls are much younger. These are primary school girls and the boys are in middle or secondary school. But none of these pictures have anything to do with the classroom. 'Class' is also a word for a group of children. A teacher can say in English: 'class', [Mieke claps her hands] and she means 'children'. This is the most clearly posed of them all, but all three have a relationship to the photographer, and that is most relevant for me. They don't have a relationship with the painter, because as I said, she paints from photographs, but to the photographer they are trying to look nice, brave and sweet. This one even looks angry and annoyed to have to sit there for so long. However, none of the three paintings have to do with teaching or education.

Social Confinement

The best way of understanding Dumas' images of the teacher, the Turkish schoolgirls and the schoolboys is by thinking of social confinement instead of teaching. I think the fact that the teacher is looking indifferent, her head a little bit to the side while she also looks stern, without a smile, does not make her a very attractive figure. When you are talking about teaching you are not talking about this kind of thing. In the Rembrandt we have looked at, the teaching happens in the painting. Even better, the learning, not the teaching. But here I don't see that. The stiffness is key. The painting is about social confinement and the constraint of the children having to line up for the photograph under the stern authority of that woman in the middle. Therefore, the painting is not about teaching. I don't think Dumas would be particularly interested in the teaching aspect or the lack of it in this painting. I think the painting is exploring group formation, social confinement and making all the people look the same. I don't think that when you seek to do something educational—which is your project—you need to force the issue that there should be educational situations within a classroom. For me that is not necessary. All I can say is that this not at all educational in the positive sense; on the contrary, it is straight-jacketing.

Curating

If I were to curate these works, I could go a step further and contextualize or re-order the sequence. Maybe the educational system has let the boys down and so they don't care to go to school. In the sequence that we have been looking at, that would be a logical moment. It doesn't mean the boys cannot be arrogant pricks, of course they can and they probably are. You are a sixteen-year-old and you stop learning. That is not so good. But I have no idea. You could consider the pictures as a curator. I would then be able to say, let's play with it. We start with the adolescent boys. Why are they looking so full of contempt and not interested in anything? Because they have been moulded in a way against which they revolt. So, you would curate it in different orders. I would even like to change it during the course of an exhibition, for example. I once proposed something like that to the Rijksmuseum, but they never answered. In the Gallery of Honour (Rijksmuseum) there was a beautiful installation of two paintings on each of the side walls and then three in the middle where you have a married couple. The way it is arranged, one figure looks ahead and the other looks to the man; the man looks at us and the woman looks at him. In the middle, you see a whole family on an outing. On the sides you have, on the one side, a drunk and something else. On the

opposing side, you have a nymph and a satyr. My proposal was, can I—just for one weekend—reverse the couple so they are on their way to divorce and the man is looking at the nymph and the woman is looking at the drunk? That is a completely different set up from the sort of uptight Dutch seventeenth-century moralistic set-up that they just imitate. I think that the painter never meant it so moralistically, and he couldn't care less because he did it for a patron and he got money for it. All that is irrelevant. Why not shock the public by making these upstanding bourgeois people divorce and let each go to another kind of life? That would be so nice. I did a guided tour with Norwegian museum workers, and they loved it. They said: 'Oh, yes suddenly this comes alive!' So, I sent an email to the head curator (now director) of the Rijksmuseum but I never got an answer.

Caring

Curating is caring for the works and caring for the public. Caring for the public is not the first priority. For me it is caring for the relationship between the public and the painting. But there is a distinction between curating and conservation; conservation is an entirely different issue. Conservation is really caring for the paintings in their materiality. Curating is

imagining and presenting, so that the public is encouraged to be imaginative and engaged. It requires the imagination to think about how people would respond to this, and about how I can shock them out of their expected way of looking. Because most people come to the museum to see the great masterpieces and they want to oooh and ahhhh, but they don't necessarily want surprises other than the great qualities of the works. But that is a bit difficult with this kind of work. Dumas does not make pretty work. It is always disturbing, both in subject matter and in the seemingly sloppy mode of painting. I think that is part of her strategy of shocking people into looking. Because if it almost looks like a photograph, there is no surprise; there would be nothing to look at. The relationship between the painting and the source photograph can be considered an interdisciplinary dialogue, rather than a depiction of the latter in the former.

Teaching in the Inter-disciplinary Field

I prefer to use concepts in the inter-disciplinary field of the humanities. I'm not against methods, please don't think that I am. I think methods are developed within disciplines and they can be very useful and productive. But can they also become confining.

They can also become stultified and serve as blinders; they can make researchers passive, kill their creativity. That is, you do what your method tells you and nothing else; you don't look to the side. That is the typical attitude of a strict disciplinarian. It makes some sense because limitation is also good; it makes you more precise. I don't want to casually reject methods. But in inter-disciplinary work, it is a real difficulty because you don't have a single method; there is no method for such work and there cannot be, because there is no discipline that covers it all. Interdisciplinarity is by definition multiple. As a result, cultural studies as it was first beginning to thrive and become popular has suffered from a lack of method. I think that is why people within the disciplines didn't recognize the results as valid; there was no recognizable method leading to the results. The results were more intuitively formulated, often from a political perspective and, in the best of cases, accompanied by some observations. This is not arbitrary, but if you use concepts—I'll come to say a little more about them—these are more easily recognized in different disciplines and can be discussed among them. And so, you can consider that for inter-disciplinary work the best 'method'—rather, way of working—is to start with concepts. Then you can see if there is anything possible, methodologically speaking.

Inter-subjective

The one advantage of methods is that you can teach and learn them, and so they are inter-subjective. Intersubjectivity is the alternative to an untenable objectivity. This requires serious work. The whole point of my book on interdisciplinarity is that concepts can be made inter-subjective, but you can only do that if you take into account how they travel from field to field, from discipline to discipline. This is why I called the book *Travelling Concepts*. They can also travel internationally, they can travel through history but they also travel from discipline to discipline. That is an advantage if you take the metaphor of travel seriously and look at what happens during the travel. And if you are disillusioned with methods because the methods you have been taught are too rigid, which is what many people in cultural studies ended up feeling, then you lose your perspective. It is another blindness to not see how others understand concepts differently from you. To speak to each other or to speak among disciplines, you also need to have some sort of rigour. I don't like to call it rigour because when you do that you get in trouble; it sounds confining. I would like to call it an opening up of the dialogue between one use of the concept and another, and between the concept and the cultural object. That is to say, we use it here, in this way, but how do you

use it? If you don't, then it sounds arbitrary or authoritarian.

Complexity

The point is to use concepts in a more complex way. It is like the little anecdote I tell at the beginning of the introduction or the preface of *Travelling Concepts*, about the Theory Seminar where the word 'subject' comes into play. This is actually a true anecdote; it really happened! When people say the subject of this picture is so and so, I really don't know what they mean. Then of course it becomes the motif, or the topic, the theme, but then the question comes up, is there no subject making the picture? Is there no subjective network that goes into the picture? You lose the work by using it in a simple way. I think this is simplistic, leading to a one-word or one-sentence 'this is *about* that', a summing up what the picture means instead of seeing the complexity; you miss the opportunity. This is another reason to be serious about concepts; if not, you lose the opportunity to make that concept fruitful in a more multifaceted and relevant way. You miss the opportunity to fully understand the picture. If you say the subject of this picture is Judith, it is about Judith, you may wonder: or is it about Esther? No, it is about David ... and then you triumphantly think

you have understood the picture when you find indications that it is about Judith. Well, I'm sorry, whether or not the experts agree, you have not understood a thing. What you need to see and what you cannot see because you used the concept already in that way—subject equals topic—instead of analysing what the subjective positions are in that painting. That is too bad, because that is where it really becomes interesting. Therefore, the concept used as a label does not help to analyse a picture. The 'about' question is wrong, misleading; it puts blinders on you.

Mini-theories

A concept, instead of a label, is a mini-theory. As a description, a concept is usually one word that carries in its history a whole stream of thoughts that people have carried forward with that work to give it a certain meaning. According to Deleuze and philosophers such as Paul Patton, for example, a concept is political. I can't reproduce the reasoning exactly, but it is political in the sense that it has more to say than just pointing at something and saying 'this is this', because in that way, using it as a label, you're not doing anything. I think the political aspect is important. What Patton calls the political aspect is the analytical value for me. A word is a

concept because it has a whole bunch of thought behind it. All this thought can open up again and help us see in the artwork or text different things that come together in that concept. Thus, a concept is like a mini-theory. It is not propositional; it doesn't consist of sentences. It has no syntax, but it is like a condensation of a theory. When you use a concept analytically, you are deploying it, so the theory comes out of what has been condensed.

Critical Intimacy

Travelling Concepts is my most 'teacherly' book. I wrote about the practice of teaching and I dedicated it to students. Critical intimacy is an important concept when it comes to teaching and learning. I mention in this book the work of Gayatri Spivak. She uses the phrase 'critical intimacy' when she is discussing Kant, the concept of the sublime in Kant, and she is critical of it. She says you can only be critical if you know that which you criticize intimately, if you are inside the kind of thinking that you want to be critical about. Unless you want to reject the whole thing wholesale, but that is usually not intellectually productive. She has studied Kant inside-out, the way Kaja Silverman studied Freud and Lacan inside-out. Spivak has studied Kant and Derrida, for example, and if you know someone's thoughts really well, if

you have really done that, gone through that great effort, then you can be critical of certain things; one branch of an argumentation, but not the whole thing. And that requires intimacy. Intimacy is the deep knowledge of something and then being critical. This is totally different from saying, 'Oh, Freud was wrong, since it is too expensive to keep people in analysis'. This is the wholesale rejection of a whole school of thought, a whole body of thought, for economic reasons that don't even add up. What a loss; what a waste!

Constant Effort

Critical intimacy requires a constant effort. That is demanding, but also exciting. It puts you in dialogue with the great thinkers, without subjection to them. For me this is important, especially for PhD candidates, who are more advanced than undergraduate students in the sense that they do autonomous research. They don't develop or continue the habit of only reading secondary literature, of making a summary and thinking you know something. I've seen it so many times when doing tutorials, especially at post-graduate art centres, which I sometimes do. Often, the residents tend to come up with one thing that is Deleuzian. They say: 'As Deleuze says...', and then there it is. It can be a sloppy throwing in of a

concept without examining its tentacles and implications. I try to tell this to PhD students. That is why you feel at times that you are being so critical or perceived as such. But as I said before, it is out of respect for their work that I have to be critical. I like to make them dare to take the step from Jonathan Culler to Derrida, and they can, and Culler shows them how. They don't have to read all of Derrida because Culler's books, *On Deconstruction* and *The Literary in Theory*, are fantastic. It is really very good work. You really come to understand what deconstruction is through Culler. He avoids simplicity, but is always crystal-clear. But then when he quotes certain passages, I would encourage students to take the step to read Derrida himself, and then you will see that again, that experience opens up a lot. I think that is why Culler quotes them, to give his readers a taste of Derrida's prose.

No Snobbery

I hate snobbery. Lacan, for example, is very difficult. Even more difficult than Derrida because Derrida's prose is associative, as if he is digressing all the time; Spivak's sometimes also. Lacan constantly really comes up with concepts. But these are idiosyncratic; nobody knows them and nobody them. For instance, *objet petit a*. Object small 'a'. To be distinguished

from Object with a capital 'A'. People use that, you see it everywhere, and I know that sometimes they have no clue what it means. I cannot even explain what it means. I have tried. I have gone to Lacan and I have picked up some of the aspects of it, but it is a damn difficult thing, especially in connection with, or maybe in opposition to that other one. But if you don't understand it, which sometimes happens, that is nothing to be ashamed of. But leave it alone then, instead of throwing it in. I think that it is a kind of snobbery, to just throw in concepts that are too complex to understand and therefore to deploy with any surplus value to your argument. It is the equivalent of name dropping: concept dropping. These thinkers are worth making the effort, if you are really interested in what they have to say. You don't have to do it, but then leave it. I am really opposed to that sort of name and concept dropping. This gives people the misunderstanding that this is a Lacanian analysis, but it isn't. The same with deconstruction; you have to do it seriously or not at all.

Constructive Criticism

Constructive criticism is the most important task of the teacher. I think teachers have two critical intimacies: one with the sources that they're teaching and the other with the students. You have to know how

to negotiate between the two. The last time, we talked about the dialogic relationship. The attitude that the teacher needs to be a good teacher is not being arrogant, not thinking that you are just conveying something, but to engage in a dialogue with both source and students. For a dialogue, you need to know the other person, so with thirty students in a class it is not always easy. I know that, but if you try hard enough you can reach a level of intimacy in the sense not that you become intimate with your students in that other sense of the word, because you are not supposed to do that, but to understand where what they say comes from. I think that students often bring up something, and it is useful for a teacher to have this second reflective ability and ask: where is this coming from? Is he or she just trying to be brave or trying to impress the others or really trying to work through a problem? If you figure that out you can be both critical and constructive. I really believe that the best thing a teacher can offer is critical, constructive criticism. Criticism that the student feels is meant to be helpful and not to trash their work. Although this is something that often goes wrong, especially in the very delicate relation between supervisor and PhD candidate. Because that is where the students are really working on their own, on something really difficult. They are trying to make a mature contribution to scholarship, yet it is

hard and they have not done it before. So, in that relationship they are very dependent on the supervisor to be constructive. Sometimes when you are tired or lazy you take a shortcut and you say: 'That's not good, do it again' or you say something that comes across as undermining, destructive criticism. That indeed happens; I have done it too. Sometimes you are too fast. A critical intimacy with the students and their project makes it possible to avoid this. I once had a student who, every time she had her tutorial with me, would throw her manuscript through the room in anger and sulk for days. Well, she may have been a bit oversensitive, or narcissistic, thinking that she cannot be criticized. But I may also have been too fast in my criticism; too short, too curt with my remarks.

Trust

The supervisor/candidate relationship is terribly difficult and I'm not saying I have a monopoly on wisdom; I just know it is important. I think that the first thing you realize is what a delicate relationship it is because they must trust you. You can't be too close because then it becomes pseudo-therapeutic; sometimes that is appealing to a candidate. You know, they come and say: 'I have problems' and start to tell you their problems. That is something you cannot go

into, because you would overstep the boundary and you cannot go back to the constructive critical attitude that you need. Therefore, this is another pitfall. I think it is important to realize and acknowledge that the PhD candidate feels so dependent, because if you don't appreciate the work, who is ever going to see it, let alone appreciate it? The only thing you can do—I have learned over the years—is to be open about it and be constantly hyper-critical, but in a spirit of: I know you can do this, but there are certain things you have not yet done. Don't forget that at the end of the day, there is a committee that has to approve the dissertation, and I am not going to subject you to a committee unless I know it is good enough, as good as you can do. That is also a kind of protection. My criticism is also a protection of the candidate not to be rejected on the level of the committee, which is horrible of course. It happened once in my career and I'll never forget that. It was not because the dissertation was not good enough; in my view, it was good. It was because half the committee were theologians and they did not appreciate her freedom with the text, so they rejected it. This was an issue of disciplinary boundary-policing. I then said, OK, revise it so that a committee without theologians can approve it. So basically, I rejected the committee and the second time it was fine. Sometimes you make mistakes in composing the committee.

You think someone is good for the committee because of some element in their intellectual profile that matches the candidate's work, but that is a misunderstanding. It can happen, and it can be disastrous: discouraging to the extent that the candidate turns her back on the intellectual work she had set out to do. You kill the intellectual desire.

Education

When we were looking at the Dumas paintings I briefly mentioned curating. Curating is in a way educating. Curating for me is encouraging the audience be to shocked, engaged, and thus to create a tension; this compels them to look again and be curious. The distinction is really between the words didactic and educational. It is educational, but it is not didactic. Didactic would be the traditional way of doing it by going there with pointed finger and saying 'here you see', confirming that in the seventeenth century, that is the way it was. But of course, in the seventeenth century there were also naughty people, and there were others than the upright-uptight bourgeoisie, and it was not so homogeneous as we now think it was. Moreover, that would not speak to the contemporary audience in a way that relates to their own lives and experiences. Therefore, I think it is important to make it not didactic but

educational, in the sense that you incite people to learn for themselves. There is no exam at the end of the tour, but you can certainly help them to learn.

Narcissism

This raises a dilemma. The danger is that you see the curator instead of the artwork. I think that curators can get very narcissistic, so as to make their own poem about the ensemble of paintings. Rudi Fuchs sometimes did that. I really respect him and his curatorial work. He becomes very enthusiastic and does have a fine eye; he makes interesting combinations. But it can overwhelm the work. I don't think that necessarily happens so easily. All curation, also traditional curation, is always making an ensemble, it is never just a scattered number of individual works; it is never just these paintings. There is always a surplus of meaning in the combinations. I don't find it problematic as such, but it can be if it is too idiosyncratic, too difficult to follow or too narcissistic in the sense that you see exactly how this curator thinks and what his taste is. Then it might be a bit a distracting from the work, and from your own dialogue with it. Sometime you want to push the curator aside and say to the work: 'Let's just talk, you and I.' But I don't think it's such a big deal, traditional historicizing curation I find more problematic.

Intellectual Friendship

In antiquity, educational thinking was based on something like intellectual friendship. The philosophers were educationally oriented and they had passion as a model, which they sometimes practiced, such as pederasty. Lorraine Code says that if we have to have a model for teaching it should not be passion, because passion is blind and biased. Passion is selfish. Friendship is a much better model, and in *Travelling Concepts* I enumerate the features of friendship that are quite appropriate to apply to teaching. I think it really goes back to critical intimacy. Friendship is partial; you have more than one friend, for example, so it is not exclusive, which is totally important in view of teachers who have one favourite student and pay no attention to the rest. The others are snowed under by that enthusiasm which does not involve them, and that is very bad. In that sense, friendship is more democratic, and it is also constantly under revision and renewal. It is an affective relationship based on trust.

Notions

Friendship is a notion, not even a concept, in the sense that everyone just knows what it is. However, if you unpack the aspects of it, it can become a concept. For example, there is loyalty involved. If I

think of the Theory Seminar I ran for fifteen years. Why do you think that after every session I went to the pub with the participants? To continue the discussion. The idea was to make the transition from the orderly classroom situation where we worked to really discussing issues more freely, but also to convey a sense of friendship. Because that is what you do, you go to the pub with friends, rather than with your teacher. Friends happen; they show up. I remember one friend I had for years. I met her during my second year of high school and we were put next to each other and we started to talk and something clicked. We continued in the break and went to each other's home. That is how it begins, but the point of friendship in this educational discussion is that it's not passion.

Knowledge Construction

Friendship as a model gives a view of knowledge. Knowledge that is not achieved at once, but develops, like friendship does. Knowledge that is open to interpretation at different levels because friendship also has different levels and you can have moments that it goes down and other moments that it goes up. It admits degrees: you can be best friends or you can be just one of a bunch of friends; it changes. This is really important; it changes because it is a human

social process, and so knowledge also changes, in particular subject and object positions. The processes of knowledge construction are reversible. This is what we have been talking about, that there is not a subject and an object, but that it is a dialogue; it is a never-accomplished, continous process. It is a process, hence the idea of life-long learning.

Teacher Training Tragedy

The tragedy of the teacher training programmes is that the students are not there. You cannot train alone. The result is that there are not really enough good teachers to set the example. There are lots of good teachers but they don't necessarily have the self-reflection to be able to explain things sufficiently. I don't think I would be so eager to go teach a class and at the end be able to say: 'OK guys, you know why I'm such a good teacher?' You just don't do that. You do the best you can while you do it, and that process is what you are invested in at that moment, and then to say why and how would make it artificial. This whole process also depends on the students—how it happened. I wouldn't be able to say... I wouldn't be a good teacher in a teacher-training programme. The only thing I can do is teach myself, and write books and make films, and maybe this is my contribution to that. I don't have much more. I

have been teaching for many decades and I did the best I could at the time; that is the only way you can convey what you find important. I think that people do learn from that. I taught people in the Theory Seminar not only about theoretical issues, but also about how to 'do'.

Handbook of Teaching

First of all, you are not going to get a handbook of teaching out of me! That is not my job, or my talent, or my desire. In the social sciences, education can become a science in itself, and there they develop rules. They don't ask the question: What is it that we want them to learn? Whereas in the humanities, that is where you start. We want the students to learn how to engage with art and literature and understand and enjoy them. Therefore, if you have this kind of separate Department of Education there is no content; all you can do is read other people's books on how to do it.

Teaching as a Practice

Furthermore, I look at teaching as a practice. And I think it is OK that they say that to you about art-based learning because it is better than nothing, and it is what you do. You know that there are a million

things they could say that would be worse. I also wouldn't say you are *from* art-based learning, as if that was a department or a discipline; you *do* art-based learning. I think you should keep using the word art-based learning because I think it is a really nice phrase and it works. Therefore, when they say, 'So your method is art-based learning?' you say, 'No, it is not a method, it is an approach and a way of doing things'. When they reply, 'OK, then it is a method', you then say, 'If you call that a method, then fine. I don't mind, I don't care what you call it, as long as it is not a handbook that says step 1, step 2, step 3.' If people are coming to you with the expectation that a method is a method and that you need methods, I wouldn't bother to pick that fight. Say: 'I don't have rules for this method; it is a practice.' Call it a practice and say how you do it, then others can see if they want to do it the same way.

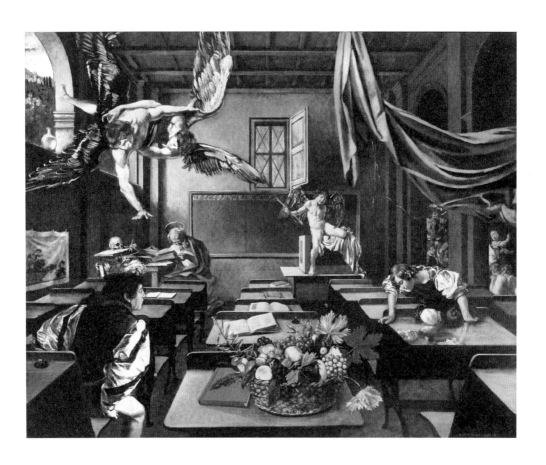

George Deem, *School of Caravaggio*, 1984, c/o Pictoright Amsterdam 2018, oil on canvas, 86 × 106 cm, private collection, photograph: Chris Ho.

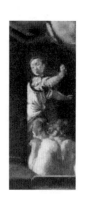

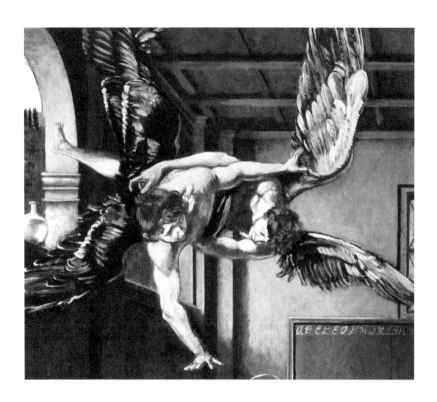

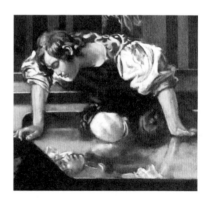

A Need for Creativity

Although Rembrandt was the best biblical scholar around, he was not a scholar. The difference is not so enormous. I think scholarship also needs creativity, but when I say Rembrandt was the best biblical scholar it is because he was creatively reading the biblical texts and making paintings that are interpretations of the text that make much more sense than most classical philological interpretations.

The Uselessness of Schools

The first thing I see when looking at this painting is the uselessness of schools. That there are books but nobody is looking at them because they are pictures; all these 'students' are also only pictures. Hence, the books are redundant. Three of them are closed and the open ones have no writing; there are no students. So, it is making a statement about the uselessness of schools, of the classical school with books (only).

Instead, you have all these guys doing things that are out of place in schools. It comes straight out of Caravaggio, so they do nothing different from what they do in the Caravaggio pictures, but it is fun the way George Deem painted them, in the present time. I love this picture not because of the school situation, and I really don't want to make this an image about education, but it is nevertheless a composition that uses the space of a classroom to bind together figures who, in Caravaggio, are unconnected. I love the way Deem disposed these Caravaggio figures so as to make sense of the scene. Like this would be a class of truants, people, teacher and students alike, who revolt against a contained stultified kind of education, of which the old-fashioned classroom becomes a metaphor. They can talk with Dumas' schoolboys.

Self-involvement

The teacher, Saint Jerome, is a self-involved Narcissus. He is not paying any attention to the school, to the class; he is just looking at his book, or rather, at his own hand. He has his hand there probably to start writing something. The figure in the wing on the extreme right of the picture seems horrified by something, and nobody is there to help. It is as if he is there on his own because he is outside the

scene. The two angels in the air, although they are flying, are also fighting, or making love. Fighting and lovemaking, in visual art, are often ambiguously close to each other, which I like. I think paintings thereby show something that we know about social reality: why men like to fight. Then the guy on the left in the foreground seems a sort of schlemiel who's sitting there, just looking; he doesn't even know at what. He is just astonished and looking. But the real eye-grabber is the basket that has nothing to do with anything; it is in the foreground next to the book. So, this is actually, this little bit—I am just improvising as you know—is making the statement that *reality* is more useful for learning than books. The book is closed; the book is useless, but the fruits are available. That is the reality and of course, if this is a classroom, the children are adolescents and Eros is there ready to strike.

Self-caressing

This picture of Eros in the back, significantly placed in front of the blackboard and the open window, is about self-caressing and self-love. *Eros Triumphant* is one of the sexiest pictures that Caravaggio ever did because of the whole pose. But there is another one in Rome that is even sexier, where you have the same pose but then with John the Baptist, with a fur

underneath his thigh. Because, of course, the sexiness is not the penis, but it is the thigh that you see being squeezed; it is such real-looking flesh that you want to reach out and touch it. So, this little muscle part here, this part where you see that he is actually sitting on something with his thigh, that is what makes the Caravaggesque naturalism and its eroticism both, that little bit. I think I have the picture somewhere in the book. It is the naturalism that makes it sexy. That is also why he was criticized for centuries afterwards. And then the creature's wing in *Eros Triumphant* is caressing this part. So, it is also masturbatory. It is very much about self-caressing and self-love, but he at least is looking for a target and maybe he is going to hit on Narcissus or thinking 'which boy shall I hit on?' and meanwhile he is making himself sexy with these little details. Is that enough? This is of course very classical baroque. Classically baroque drapery, which is what Deleuze writes about. The fold. Here is where you can tell: the drape is like a theatre program and its fold. The secret of the fold is that there is no linear perspective. The perspective is going in and out. Well, what does that remind you of? Going in and out and you come out *changed*. That is the idea of the fold.

Disorder

Looking at Deem's picture, it appears to be a kind of disorderly space. It is a theatrical space; it has a view to the outside here on the left and a view to the fictional outside there at the back. But what is interesting if you look at this as a space is that the linear perspective is completely systematic and redundant; it is irrelevant that there is no teacher here. He should be here if he were the teacher in the classical classroom, but Saint Jerome is sitting on the side and he is not doing anything with the boys; hence the disorder, the disorderly conduct of these boys. It is theatrical to show that the theatrical set-up doesn't work. Ordinarily, there would be a pupil here, here, here, and they would be sitting at their desks and doing the work that he is talking about. However, he isn't talking about anything. There are not enough pupils and too many boisterous boys. There are enough of them to wreak havoc, and to do things you are not supposed to do in school. For instance, Narcissus is looking at himself—this is a little joke on the artist's part—in the varnish of the desk. That is just like water because he sees himself, which is a funny little joke; that wouldn't be the case in reality, but of course this is not reality. I like this picture. It's too bad Caravaggio died so young.

Missing Students

A school without students is the theme of Deem's *Everybody's Schoolroom*. It must indeed be in the same series because he had this whole collection including Picasso, Matisse and Degas-like schoolrooms. In *The School of Athens* the perspective is used as it should be because that's what Rafael would do, but Caravaggio would not, so here it is not happening. It is interesting that in *School of Caravaggio* there is still fruit: here, apples. That is the little conundrum, what the apple stands for: transgression. So that is the little sign, the symptom that there are actually no students here. In *Everybody's Schoolroom* there is no fruit. The students are gone. These people in the back are all teachers. There are no kids. These are boys; adolescents.

Not Understanding

Deem's picture is an encounter between cultures—and that includes between times—in which not understanding is just as important as understanding. This is a significant point. Pictures like this are instances of 'preposterous history'. They open up thinking about the relations between past and present. After I wrote the book on Caravaggio seen from contemporary art, a lot of public interest in

preposterous history arose, but they called it anachronism. The term anachronism is something that I now also use sometimes, because everybody does, but anachronism has always been the taboo of history. You could never get away with an anachronistic interpretation. That was the worst sin. I think they have a point when they say you cannot just project from the present onto the past, not any more than you can project from your place to another culture. I may have already told you about the American anthropologist who interviewed young women in China in a village who were going to be married off to someone in an arranged marriage. This anthropologist comes in and bluntly asks them: 'How about love?' 'What do you mean?' the young women reply. This was a clear case of projecting Western values onto a different culture. Moreover, the question presumed that there is a contradiction between an arranged marriage and love, whatever that means, and well, we know how 'successful' many love marriages are. That is a case of projection. The same happens with anachronism if you do it without knowing that you are doing it. That is what historians are rightly against, this sort of flattening of time and pretending that everything is the same and that you can reach the past if you search well, dig deep enough.

Learning From Others

I think it is really critical to realize that you can't understand everything and that is how you know you must learn from others. I think historians are right to object to that sort of anachronism. But, if you do it in the way these artists do, that is, you pick up something from the past and turn it around and look at it and think: 'What can I do here to contribute to understanding art from today in relation to this past?' then I think this is tremendously productive. For example, Deem is doing such questioning. He is explicitly bringing out the homosexual tendencies in Caravaggio that nobody dares name because that concept didn't exist then. True, as a concept, it didn't, but as a practice, a desire, it did. I'm sorry, there is no reason to assume that it didn't exist. I think, on the contrary, you have to say, yes, but it didn't have that name and it didn't follow the same habits; it didn't have the same clubs, it didn't have the same fashions in clothing and behaviour that we now associate with people who want to show that they are homosexuals, not because it didn't exist but because it wasn't a big deal. Not because they were prudes; on the contrary, it was because many did it. And beginning with the Greeks, you know that. So, I think that it is an aspect of this painting that illuminates our hesitation to accept that our practices existed in other times, and exist in other places. That

is why there are only boys. I normally object to a world without women, but in this case I can totally understand that this is a boy's club.

Reflective Anachronism

What we are talking about is a sort of reflective anachronism. It is an anachronism that you want and need, hence, that you perform. It is something you practice instead of something you do unawares, acknowledging the difference between the present and the past. But if you are aware of it, then anachronism can be a tool to understand the value of certain things from the past in the present, for the present, and why it is important to still bother with these things. Why do we bother with old art? Not because we are all antiquarians, but because this art has something to say to us that today we don't quite grasp. Which is not what Rembrandt or Caravaggio wanted it to say, because they are not here. In that way, you demystify the whole concept of the truth of history and you re-make it, as a text. Also, in the 'digging up the past' form of history you are not working *with* the text. I understand 'with' in history as meaning that you are working in dialogue with the text. This is the image. Some historians think that, because they are the experts, they own the truth. But they don't.

Unorthodox Arrangements

Deem's school-series consists of elements (re-)arranged in a very unorthodox way. He knew very well that these guys don't belong in a classroom. And then you have this phrasing in his titles: 'The School of...'. In the art-historical sense, 'school of' means followers. Deem doesn't follow Caravaggio but copies him literally, and *rearranges* the elements. Caravaggio would say, 'Hey, hey, wait a minute, you can't have this boy with this boy'. Well, you can. I wrote a big book of 300 pages or so on Caravaggio, and noticed that in every painting he does you have it all condensed, even if each painting is very different. It is like a theory of preposterous history. He says: Look, the Baroque perspective of the fold, that is exactly this, going in and out, and then you see him sitting here and then you know what you are going into and out of. Thus, taken together, these elements tell us something about the erotic nature of Caravaggio's fleshy paintings, as well as his vitalization of a different kind of perspective. I think that the elements all contribute to that generalized erotic, or most of them do, and that makes sense and undermines the other, more orthodox, linear perspective. This is completely undermined because here, there is no such perspective, and we don't need it, we don't miss it. In this sense, Caravaggio undermines the classical, and Deem draws attention to that.

Anti-structures

Deem is showing an anti-structure. In the structured way, these boys would be sitting at the desk and the teacher would be standing here and they would be listening intently. But he just gave up; he is doing his own thing and these boys do what they want. So, they are doing in a classroom something you never do in a classroom, and that is preposterous history. You do with history something you would ordinarily never do with history. It is just to say: 'I take this because I find that exciting.' And if we then go from here to something that for me is the quintessential preposterous history, it is this combination. My book's cover and title page demonstrate what preposterous history is. This was not actually my choice. But when I saw this, I thought that the designer had read the manuscript and perfectly understood it. She must have read and understood the whole book, because this design summarizes the book. A figurative and an abstract version of preposterous history. This is my favourite erotic Caravaggio, it is such a beautiful one, but there is another one with the fur underneath which I just discovered, and that one is even sexier. Here the fur is over his loin but there is still another one that is even more erotic. You see the furs, sitting here, but there is another painting where the fur is under his thigh.

Desires

Education, here, is about making people understand their own desires and possibilities, hence the place of Narcissus in Deem's image. Which has now been dis-attributed, I'm sorry to say. *Narcissus* is no longer considered to be a Caravaggio, they say, but I've always loved it. Narcissus, that is the one who is looking at himself; that is the whole point of Narcissus. He is looking at himself, he is discovering himself. 'Learn to know yourself', and perhaps the schlemiel who has nothing to do is looking at him and thinking, 'Yes', instead of listening to the teacher, and maybe he is thinking 'I should think about myself'. In the culture of selfishness and total self-involvement that we have now, where the aesthetic of the street is the selfie, I don't need this message. But I think there are a lot of boys and girls who are in this situation where they are not sure of what they want and that whatever their desire may be is acceptable; they may need this message. The sex is like the anti-structure, against the structure. Do you know how you can kill this image? It is very easy. Suppose you give as homework that they have to trace all Deem's paintings back to the source. Come back tomorrow and tell me the date, title and location of each painting. That would be the art historical iconographic lesson, and then the painting is dead. It is gone! Because he put them together and

that is the point, and if you then take them apart again, you may just as well go and look at the original Caravaggio paintings. But that makes no sense. I think it is a beautiful painting; I love this picture and it is one of his really profoundly 'thinking' works. Let me see how you see it. You see it like this. The thing itself is a fold. The work itself, does it have large dimensions? It probably does. It is an assemblage and it should stay an assemblage because that is the point. Deem puts things together that didn't belong together in the past; but, he says, today they do. So, the better homework assignment would be: think about how the different elements hang together.

On Its Own Terms

It is a view of the work on its own terms. Everybody assumes that Caravaggio had boyfriends, but nobody will say it out loud, and if you do, they say 'that is an anachronism'. To say he was a homosexual is an anachronism. I said that about Descartes and I received that reply from really good friends who are actually quite smart. I said, yes, that is an anachronism and I want it to be an anachronism. I want us to understand him on his terms as their meaning would be now. That is actually what preposterous history is; to try to understand art from the past on

its own terms brought to the present. How can it still be on its own terms? Well, here the term would be the naturalism of Caravaggio's mode of painting that is very important, much more important than the religious message that many of these images also have. He got paid for the religious message, not for the erotic representations. Still, many cardinals were having a lot of fun with the erotic side of those, and some of these pictures even appeared in secret cabinets in their private quarters. It is not as if Caravaggio was the only one doing it. It is the sort of thing that you are not supposed to really talk about.

Space of Negotiation

You could say that preposterous history is the production of a space of negotiation. You bring the painting into a space of negotiation, which enriches both parties. Therefore, Caravaggio is enriched because he could not know how wonderfully his use of space would fit with the cinema. How could he know? And yet some of his work is incredibly cinematic. So, he is enriched and we are enriched because we only had the cinema; now, we also have this fantastic art and we can bring them together so we are also enriched. That is, I argue, the value of preposterous history: 'How does this work together then?' I know from working on Flaubert and cinema

in a curatorial project (at the Munch Museum in Oslo, 2017) that while there was no cinema in Flaubert's time, he used cinematic ploys and devices; he had the method, he was behaving like a film director. He would go out in the streets, to reconnoitre, to find the right site to set certain scenes of his novel. Well, that is what a film director does, or they send out location scouts. And then he would say: 'No, I want *un gros plan*, a close-up, but for this I want a wide shot.' I mean, Flaubert didn't use those terms of course, but he used the ideas, as incipient concepts, absolutely right. He wrote what he actually called scenarios. I think authors like Flaubert at that time made it necessary to invent the cinema.

Reversal of Time

What matters is less the clear historical positioning of an object, but rather the constant reversal of time, as becomes clear in the work of Flaubert. It is not that the cinema was projected back onto Flaubert; no, Flaubert was doing cinema, so the Lumière Brothers had to invent the tools to make cinema real. I am making that argument in my book on Flaubert, Munch, and video art. People like Flaubert made it necessary for something to be invented that would help that mode of writing along. You can say something similar about the reversal of time in this. You

mentioned the theatrical, and of course all of Caravaggio's work is theatrical. He had people posing for him in his studio; the man 'playing' Saint Peter on the Cross was spending hours and hours, probably days with his head down on the cross. You can see it in the painting because of the nails; he's cramping. You can imagine how when you have nails through your hands, it would be cramped, but here you can see that the nail is not straight because rather than going through his hands, he is holding the nails; he got tired and let one of them slack. That kind of detail is important. It is like the earring of Lucretia in Rembrandt's 1664 painting. There, the oblique position of the earring indicates that she is moving her head, as if turning away from the viewer. You can see details that betray involuntary aspects of theatricality, but I think it was actually not unconscious; I think it was completely accepted that this was theatre. So, there was no reason to hide it. If the guy holds the nail obliquely because he was too tired of posing—I would be, too—then let it be. You see?

Theatrical

It is all about the theatrical. The sagging body: you would not see it that way if you didn't know the painter Francis Bacon, so you have to bring Bacon to the past and then back again. And of course, Bacon

looked at these paintings, but the opposite also holds, that Bacon foregrounded that aspect of Rembrandt, and Rembrandt invented Bacon in the way Flaubert invented the cinema. The theatrical is emphasized instead of hidden. And then we realize that Rembrandt would not put have himself in the scene if he thought he had done a totally authentic historical reconstruction. He knew he had not. He had a chest in his studio full of clothes that he had bought in the flea market, and that is what he used. He did the kind of paintings that I do in film, of course, *toutes proportions gardées*. I don't care whether it is authentic because it never is, but here and there I want to bring in a *touch*—suggesting: think of history!—and therefore I would put something in that invokes, but does not represent history; just a little thing in the costume or a little flourish in the make-up where you could see, yes, this is theatrical, and it has a link with the past, but we see this in the present.

Teaching and Creativity

What we need most is creativity. We are meant to go beyond the present. I think it is really important to give artists like Rembrandt credit for having been creative. They are artists, right? They were creative, they were not scholars. As I said earlier, although

Rembrandt was the best biblical scholar I know, he was not formally a scholar. I think scholarship also needs creativity, but when I say Rembrandt was the best biblical scholar it is because he was creatively reading the biblical texts and making paintings that are interpretations of these texts that make much more sense, creating a surplus of understanding. I don't know an example by heart but there is an example of a Samson painting or drawing where you can see that Rembrandt understood the story better than the people who had always come up with the same interpretations. If you are interested, I write about such cases in my book *Reading Rembrandt*.

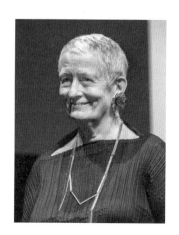

Roland Barthes, 1978,
photograph: Sophie Bassouls.

Walter Benjamin, 1937,
photograph: Gisèle Freund.

Mieke Bal, Luzern, 2016,
photograph: Roberto
Conciatori.

Epilogue

The work of Walter Benjamin inspired me as a teacher.
I think he is a powerful teacher because he is honestly *there*.
He doesn't hide behind big theories, he is there, he is doing
it, he is seeing, he is describing what he sees, and I like that.

Teaching Enthusiasm

My teachers taught me the importance of enthusiasm. It is really funny, I got this question before when they did a television film about me. The director was pushing a bit: Was your mother a role model for you? No not at all, on the contrary, she was what I didn't want to be. But the inspirational teachers were indeed people I aspired to be like, or with, or borrow some gift from. I once had a French Literature teacher called Kibédi Varga, who was Hungarian. He had a beautiful male voice, the kind

that you could fall in love with. You know the feeling. He spoke French beautifully. My feeling for poetry, as for the Verlaine verses we discussed earlier, comes from the combination of what he told me about the poems and the sheer sensuous quality of his voice when he read them in French. I aspired to speak such sensuous French. I had another teacher called Paul Zumthor; he was a French-speaking Swiss. Varga was not a native speaker, but Zumthor was. Yes, Varga had the more beautiful French voice. Zumthor was a medievalist and I never had any interest in medieval literature before, not particularly. He taught a course that started at nine o'clock in the morning; it was the earliest slot in the university and I went there every week. I didn't realize why I was so keen on this course; it was not because of the Middle Ages, although I did do some more reading on the topic later, but because of the contagious enthusiasm that made him write on the blackboard on and on and on, and then at the end of the very large triptych blackboard, he would be in trouble because he couldn't fit his thoughts on it anymore. For me, his exuberant mind was so active that it didn't fit on the blackboard. That remained a metaphor for me. So, from him I learned enthusiasm. He said at some point: 'If you want to write quickly, just forget the accents and the dots, the commas and all that.' That I did not agree with, so I also knew this

was dialogic, not an invitation to slavish imitation. I thought it was fantastic, this enthusiasm that made me enthusiastic, but eliminating the dots and the commas and the accents means you are hurting the language and I couldn't stand that, because the other teacher with the beautiful voice had instilled in me respect for all the nuances of the language. So, I knew what I did and did not want to be inspired by all of it. Therefore, people all have an impact.

Roland Barthes

You mentioned Roland Barthes. Do you know what he did for a living? He was a primary-school teacher. Like Mallarmé, by the way. Yes, Barthes is one of the good interpreters who do what a teacher should do, but even though you cannot expect all teachers to be so brilliant at interpreting art, they can lead you to details. I have had two encounters with Barthes. I didn't know him personally. The first occurred when he came to Leiden to give a talk for the students of French. At that moment, I was already very combative, a student activist, and I was constantly protesting with student groups against the ridiculous norms for the exams and the lack of support to make changes. I also thought they should do a better job with the teaching, but they didn't have enough teachers. Then Barthes was ready to give the talk

and I took the microphone away before he got a chance to say a word. I said: 'Folks, get out of here, this man is only eating up the money that should go into teaching.' I didn't know this was the Roland Barthes I would later read and admire. I was just shouting to the students and then I left and of course didn't hear what he was talking about. Later I heard that he had presented the essence of *S/Z*, which is his most important book, a close reading of a Balzac story. So, I was a little embarrassed. I wrote about the experience in an article called 'The Rhetoric of Trashing'. This was completely thoughtless, stupid behaviour on my part. But then, a few years later I was writing about *Madame Bovary*, which was my first writing. Somehow, I was invited to present it at a *journée* Flaubert in Paris; I was giving the lecture about description. Later, I heard that in the hallway (the door was open), there was someone listening, pacing back and forth, and that was Roland Barthes. The person who told me this said: 'Well, you know Barthes, you never know if he was a trendsetter or a trend follower.' This would be one of those moments that he was maybe picking up something. I don't object to that so much, as it was a funny kind of revenge, an opposite situation. Those were my two encounters with Barthes.

Walter Benjamin

You asked me about Walter Benjamin. The work of Benjamin inspired me as a teacher. I think he was a powerful teacher. I want to show you a quotation that is programmatic for preposterous history. It just is. I cannot find the quotation in a book; I just have to look it up on my computer. Yes, here it is. 'Every image of the past that is not recognized by the present as one of its own concerns threatens to disappear irretrievably.' That is Benjamin saying we have to see the relevance for now, or we lose the image, irretrievably. He then says, at some later point, something like: it comes by in a flash and it immediately disappears, so grab it. This is the expression of the importance of preposterous history, isn't it? Recognized by the present as one of its own concerns. That is a great inspiration.

Kracauer and Adorno

Benjamin, Adorno, and Kracauer are important. I have just written about Benjamin's 'The Angel of History', in *In Medias Res*. There I wrote about it using another term that we don't have on the agenda in these interviews, which is the 'thought image': image as thinking. There are people who now say that images think. For me that is a metaphor. I have used it, but I don't anymore, because people really

take it literally. If images think, then where is the brain? But the thought image is the equivalent of the German *Denkbild*. It was even a genre, a literary genre in the twenties of all these people, such as Kracauer and Adorno, who had to escape to America when things began to heat up in Germany. Benjamin, who committed suicide instead of escaping, also participated. They were all making thought images, *Denkbilder*. These were not images but texts; it was a literary genre. It was depicting, it was almost like an aphorism or a haiku, a short story, a micro-narrative they call it sometimes, where there is something that you see and because it is short you see it really briefly. Benjamin's short on the Angel of History was not written as a thought image; it is part of the 5th thesis on the philosophy of history, but for me it is quite precisely a thought image.

Confrontations

I have had confrontations with teachers—sometimes quite amazing—with the most inspiring ones. I am now a retired teacher myself and sometimes think back to those confrontations. I had a teacher of French who set me on the track of *Madame Bovary* and who was fantastically brilliant. I loved her classes and she was a native speaker of French, so her French language was a pleasure to hear.

Sometime later, she was teaching a seminar for doctoral candidates but I was still studying for my undergraduate degree and asked her, 'Could I please attend your seminar?' and she allowed me to do so. The seminar was on 'description'. I then said I would like to write an article on description in Flaubert's *Madame Bovary*. What do I do, where do I start? Now, here comes the worst teaching ever. What do I do? I mean I was a student, I did not have enough knowledge. She said: 'Read everything on Flaubert.' Which was a way of sending me packing. Right? It's a long story; I became very good friends with this teacher later in life, and now every time I go to Paris, I look her up. She is now very old and frail. She wanted to play a little role in the film *Madame B*. This made lovely symbolic sense since she had pointed me to that novel decades ago. So, we arranged it, but then there was a taxi strike, so she couldn't do it after all. Anyway, I went to see her and somehow, we came to talk about this. Boldly, I asked: Do you remember you said that? Because I always wondered if you were being stupid or nasty? She replied, 'nasty'. 'I didn't want you to write the article', she remembered. I was in tears, that she was so honest, that fifty years later she would say this. I said 'I can't believe that you're so honest, that you not only remember but also tell me', and she said 'I have felt bad about this all my life'. Now we are

the closest of friends and she is lovely. This was just a moment when she was insecure herself, you know, problems and rivals, the academic snake pit. My then-husband was a rival of hers, and that is why I could not befriend her at that time. But when I did write the article, of course I didn't read everything on Flaubert, I just read a few bits and pieces. I am very good at picking the right things, so I was fine. I also read some of Barthes' work. I then showed her the article and she saw that it was good. She must have felt guilty at that point because she helped me to be invited to the seminar in Paris. Therefore, this is not a story about someone who is nasty; it is a story of someone who, at one moment in time, had a nasty impulse as we all do, and then made up for it at the first opportunity that presented itself.

Guidance

I think that real education is considered outmoded in universities and academies, although students need a little guidance. It is seen as old-fashioned. You don't do that. The reduction of programmes means that everything is now crammed into three years. Students have to do or rather know this, this and this, and those are the end terms and that's it. And no, it is not getting any better. Students want to learn to think. But they need some guidance in

where to go, how to learn. Because, if not, whenever they stop to think they are going to feel: 'I'm wasting my time; I should be cramming for this exam.' And to constantly learn about the value of experience, the value of stopping for a moment to think, is something that they don't do automatically.

Teaching the Unique

I focus on the unique, the specific. True, the waning interest in the humanities—compared to the social sciences—is terrible. On the other hand, if you generalize, for example about the contradiction between social sciences and humanities, I think you are going to be completely judgemental. There are no laws. No. Actually, I am quite proud that I'm awarded an honorary degree from the University of Luzern from the Humanities and the Social Sciences combined. I am proud of that because it means, at least at that university, that they acknowledge that some of my work is relevant beyond the 'little case'. It is obvious for us, or we wouldn't be sitting here today. That is why *Quoting Caravaggio* is not only about Caravaggio, even not particularly about the contemporary artists in this book, but about our view of history and that is something that is more general. Therefore, there are always generalizable bits and un-generalizable bits, and if you lose sight of the

latter and forget that there are these *unique* specific, singular things, you lose art. If you lose art, you lose culture; if you lose culture, you die.

Literature

NARRATOLOGY

Bal, Mieke. *Narratology: Introduction to the Theory of Narrative*. Translated by Christine van Boheemen. Toronto: University of Toronto Press, 1985, 4th revised edition 2017.

———. *On Story-Telling: Essays in Narratology*. Sonoma, CA: Polebridge Press, 1991.

Herman, David. *Story Logic: Problems and Possibilities of Narrative*. Lincoln and London: The University of Nebraska Press, 2002.

This is an attempt to recast narratology in a cognitive framework.

TRAVELLING CONCEPTS

Bal, Mieke. *Travelling Concepts in the Humanities: A Rough Guide*. Toronto: University of Toronto Press, 2002.

Patton, Paul. *Deleuze and the Political*. London and New York: Routledge, 2000.

In this study, Patton analyses Deleuze's view of concepts, with a clear explanation of the political force of concepts.

Hyvärinen, Matty, Mari Hatavara and Lars-Christen Hydén, eds. *The Travelling Concepts of Narrative*. Amsterdam: Benjamin Publishing Company, 2013.

This collective volume presents the views of the importance of concepts relevant for narrative analysis in a wide range of disciplinary fields.

CLOSE READING

Close reading goes back to the first half of the twentieth century in reactions against the historical-contextual criticism. Because of a renewed interest in context it was waning around the sixties, when structuralism became dominant. With the impact of deconstruction, the practice had a comeback. See

Cohen, Tom, ed. *Jacques Derrida and the Humanities*. New York and Cambridge: Cambridge University Press, 2001.

I have pleaded for, and practiced close reading in all my published books. For visual analysis, see esp.

Reading 'Rembrandt': Beyond the Word-Image Opposition. Cambridge, UK, and New York: Cambridge University Press, 1991, 2nd edition (paperback) 1994, reprint Amsterdam University Press, 2006.

And for literary analysis based on connections to the visual, see esp.

The Mottled Screen: Reading Proust Visually. Translated by Anna-Louise Milne. Stanford, CA: Stanford University Press, 1997.

For a brief discussion of close reading in teaching, see ⟨https://www.weareteachers.com/strategies-for-close-reading/⟩.
A somewhat elaborated example is here: ⟨http://web.uvic.ca/~englblog/closereading/⟩.

PREPOSTEROUS HISTORY

Quoting Caravaggio: Contemporary Art, Preposterous History. Chicago, IL: University of Chicago Press, 1999.

I have further developed this for contemporary migratory culture in an exhibition project. See
Bal, Mieke, and Miguel Á. Hernández-Navarro. *2MOVE: Video, Art, Migration*. Murcia: Cendeac, 2008.

The term 'preposterous' has been replaced by 'anachronism'. An example of a study of visual art with time as its main interest is
Lee, Pamela. *Chronophobia: On Time in the Arts of the 1960s*. Cambridge, MA: MIT Press, 2004.

Index of Key Terms

Against structure 129, 130
Against typology 46–48
Agency 76, 77
Alien/Alienation 13
Alive 26, 44, 75–77, 93
Allusion 18, 41, 49
Ambition 29
Anachronism 43, 125–127, 131
Anti-structure 129, 130
Art of teaching 7
Artistic tool 51, 56, 65, 127
Authority 26, 28, 91, 97
Awareness 42, 127

Caring 74, 93
Causal questions 24, 25
Causal/Causality 20, 25
Close reading 20, 65, 69, 70, 73, 78, 142
Common goal 27
Common ground 27
Common legacy 45
Communicative 11, 23
Complications 77
Concepts 21, 22, 27, 39, 43, 45–47, 49–51, 76, 87, 94–99, 101, 102, 108, 126, 127, 133
Confrontations 144
Constructive criticism 28, 102–105
Counter-reading 24
Creative need 119
Creativity 95, 135, 136
Critical intimacy 99, 100, 103, 104, 108
Curating 92, 93, 106, 107, 133

De-categorizing 48
De-intimidate 45
Democratic 25, 26, 28, 69, 108
Democratic tool 23
De-mystify 127
De-naturalize 56
Desires 130
Dialogue 62, 64, 65, 72, 73, 94, 96, 100, 103, 107, 110, 127
Disorder 123
Doing theory 21
Dreams 78

Education 11, 21, 53–55, 90, 91, 92, 106–109, 111, 120, 130, 146
Effort 100, 102
Empowering 19, 23, 28
Encounter 13, 48, 77, 124, 141, 142
Enthusiasm 107, 108, 139–141
Experience 31, 44, 45, 61, 63, 67, 71, 72, 74, 75, 101, 106, 142, 147

Facilitate 64
Fantasy 78
Feedback 29
Fiction 18, 123
Focalization 20, 21, 24, 39, 40, 42, 45, 47, 51, 55, 56
Focalizing structure 56
Fun 12, 26, 44, 45, 76, 120, 132

Game 26, 27
Gaze 43, 75, 77
Generosity 30, 31
Grouping 90
Guidance 146

Hybrid 47

Imagination 24, 78, 94
Institutional permission 28
Intellectual Friendship 108
Inter-disciplinary 94–96, 105
Interpretation 20, 43, 46, 64, 70, 109, 119, 125, 136, 141
Inter-subjective 96, 97
Interweaving 56
Invite/Invitation 73, 74, 77, 141, 142, 146

Joke 123

Knowledge 19, 30, 31, 42, 69, 100, 109, 110, 145

Leading 74, 141
Learning 14, 19, 25, 27, 30, 47, 61–64, 68–76, 78, 91, 92, 96, 99, 105, 107, 110–112, 121, 126, 130, 140, 146
 Learning experience 72
 Learning from others 126, 140

Learning moment 44
Learning on several levels 61, 72, 109
Learning radically 63
Learning, Deep 63
Learning, Facilitate 64
Learning, Peer 27, 44
Listening 22, 69, 129, 130, 142
Little break 65–67
Lively class 25

Manipulation 22–24
Middle of things 21, 43, 45, 143
Mini-theory 98, 99
Mode of expression 39, 50, 51
Multiple perspectives 40, 54

Narrative 12, 20, 40–43, 46, 47, 48, 50–53, 56, 62, 144
 Narrative picture 11, 12
 Narrativity as a practice 39, 52
 Narrativity in teaching 39, 52, 53
Narratology 19, 45, 56
Non-engagement 77, 88
Notion 46, 55, 108

Object 7, 26, 27, 39, 52, 72–77, 96, 101, 110, 126, 127, 133, 142
Opening-up 27, 96, 99, 101, 124
Opportunities 97, 146
Opposites 48, 49, 54, 102, 135, 142

Participate 26, 45, 78, 144
Perspective 12, 13, 40, 54, 55, 61, 72, 89, 95, 96, 122–124, 128
Political 28, 55, 56, 95, 98
Political agents 28
Political tool 56
Positive relation 44
Power discrepancy 55, 56
Power relations 56, 103, 104
Pregnant moment 62
Preposterous history 124–126, 128,129, 131, 132, 134, 143
Present, The 39–41, 43, 50, 127, 132, 135, 143
Privilege 19, 28
Protection 29, 42, 105
Purpose 27, 48

Reality 18, 88, 121, 123
Re-arrangement 128
Receptive 20, 21, 23, 29
Resist terror 54
Resistance 22–24, 54, 64, 77
Respect 30, 63–65, 74, 101, 107, 141
Reversal 24, 133

Rules 26, 30, 47, 63–65, 74, 76, 87, 111, 112

Scholar / scholarship 23, 28, 103, 119, 135, 136
Seeing complexity 97
Seeing details 22, 47, 50, 61, 64, 67, 69, 70, 73, 74, 89, 122, 134, 141
Senses 77, 78
Sincerity 27–30
Snobbery 101, 102
Social confinement 91
Social fabric 45, 55
Social moments 44, 45
Space of negotiation 132
Speak-able 45
Speaking object 64, 73
Stories 21–24, 39–42, 44, 47, 48, 50, 52, 53, 56, 69, 70, 71, 136, 142, 144, 146
Subject 52, 63, 64, 67, 68, 72, 73, 76, 96–98, 110,
Subtle 49, 67, 68
Supervisor 29, 103, 104
Surplus 50, 102, 107, 136

Teacher 52, 64, 65, 67, 88–91, 102, 103, 108–110, 120, 123, 124, 129, 130, 139–141, 143–145
Teaching 11, 13, 19, 21, 25, 30, 39, 50–53, 55, 61, 64, 69, 74, 75, 78, 87, 90, 91, 94, 99, 102, 108, 111, 135, 139, 141, 142, 145, 147
 Teaching, Art of 7
 Teaching at the spot 64
 Teaching objects 7, 74
 Teaching the unique 147
 Teaching to look 69, 70, 73
Theatrical space 123
Thinking 13, 23, 24, 55, 61, 62, 77, 99, 108, 124, 131, 143
Thought images 143, 144
Thought provoking 54
Travel 96
Travelling concepts 96, 97, 99, 108
Trust 28, 104, 108

Understanding 21–24, 27, 47, 63, 78, 91, 102, 106, 124, 126, 136
Unlearn 69, 70, 78
Unique 26, 46, 147, 148
Unorthodox 128
Uselessness 119, 121

Visual language 76
Visual representation 12, 88, 132
Voyage 70

Index of Names and Organizations

Adorno, Theodor 143, 144
ASCA, Amsterdam School for Cultural Analysis, NL 18

Bacon, Francis 134, 135
Balzac, Honoré de 142
Banksy 8–10
Barthes, Roland 138, 141, 142, 146
Bassouls, Sophie 138
Bathsheba 30–38, 40–42, 54, 67, 71, 72
Benjamin, Walter 138, 139, 143, 144
Boÿmans Van Beuningen Museum, Rotterdam NL 57

Caravaggio (Michelangelo Merisi di Caravaggio) 113, 120, 121, 123, 124, 126–132, 134, 147
Culler, Jonathan 101
Code, Lorraine 108
Conciatori, Roberto 138
Cox, Peter 86

David (King) 40, 41, 97
Deem, George 113–118, 120, 123, 124, 126, 128–131
Degas, Edgar 124
Deleuze, Gilles 98, 100, 122
Delilah 69, 70
Derrida, Jacques 27, 99, 101
Descartes, René 78, 131
Dumas, Marlene 48, 79–88, 91, 94, 106, 120

Eros 121, 122
Esther 97

Flaubert, Gustave 132, 133, 135, 142, 145, 146
Freud, Sigmund 99, 100

Ho, Chris 113

John the Baptist 121
Judith 97, 98

Kant, Immanuel 27, 99
Kracauer, Siegfried 143, 144

Lacan, Jacques 75, 99, 101, 102
Louvre, Musée du, Paris FR 38, 42
Lucretia 134
Lumière Brothers 133

Mallarmé, Stéphane 141
Matisse, Henri 124
Mouffe, Chantal 55
Munch, Edvard 12, 48, 133
Munch Museum, Oslo NO 133

Narcissus 120, 122, 123, 130

Patton, Paul 98
Picasso, Pablo 124

Rembrandt Research Project, NL 69
Rembrandt van Rijn 30–38, 40–43, 57–61, 63, 67, 69, 70, 71, 77, 91, 119, 127, 134–136
Rijksmuseum, Amsterdam NL 92, 93

Saint Jerome 120, 123
Saint Peter 134
Samson 69, 136
Schindler, Oscar 54
Silverman, Katja 99
Spielberg, Steven 53, 54
Spinoza, Baruch de 78
Spivak, Gayatri 99, 101
Stedelijk Museum Amsterdam, NL 86
Studio Tromp 57

Titus (van Rijn) 57–61, 64
Thyssen-Bornemisza Museum, Madrid ES 71

University of Luzern, CH 147

Varga, Kibédi 140
Verlaine, Paul 65–67, 76, 140

Warmond, Ellen 18

Zumthor, Paul 140

Biographies

Mieke Bal is a cultural theorist, critic, video artist and occasional curator. She works on gender, migratory culture, psychoanalysis, and the critique of capitalism. Her 38 books include a trilogy on political art: *Endless Andness* (on abstraction), *Thinking in Film* (on video installations), both 2013, and *Of What One Cannot Speak* (on sculpture, 2010). Her intellectual endeavours are reflected in the essays in *A Mieke Bal Reader* (2006). *In Medias Res: Inside Nalini Malani's Shadow Plays* (Hatje Cantz) was published in 2016, and in Spanish, *Tiempos trastornados*, on the politics of visuality (AKAL). Her video project *Madame B*, with Michelle Williams Gamaker, is widely exhibited, in 2017 in Museum Aboa Vetus & Ars Nova in Turku, Finland, and combined with paintings by Munch in the Munch Museum in Oslo. Her most recent film is *Reasonable Doubt*, on René Descartes and Queen Kristina (2016). The installation version of that project has been shown in Kraków, and in 2017 in Amsterdam, Brisbane and Warsaw. ‹www.miekebal.org›

Jeroen Lutters is an art and culture analyst and educational designer. His critical educational theory concentrates on the central role of the arts and humanities in the contemporary curriculum, the need for artist educators as wandering teachers, the theory and practice of art-based learning, and the development of twenty-firstcentury educational landscapes. His most recent publications focus on art-based learning, for instance: *The Shadow of The Art Object: The Practice of Art Based Learning* (Garant, 2012), *Teaching Objects: Studies in Art Based Learning* (ArtEZ Press, 2015), *Ema: Nude on a Staircase: Studies in Art Based Learning* (ArtEZ Press, 2017). As an educational designer he participated in several multi-level and interdisciplinary educational designs with a focus on creativity, such as: the Bernard Lievegoed University (Driebergen), Teacher College (Almere and Zwolle), ArtEZ International Research School and International Master Artist Educator (Arnhem), and No School (Eindhoven and Zwolle).

The essays in this book are licensed under a Creative Commons Attribution-Non-Commercial-NoDerivativeWorks license.

The user is free to share – to copy, distribute and transmit the work under the following conditions:
○ Attribution – You must attribute the work in the manner specified by the author or licensor (but not in any way that suggests that they endorse you or your use of the work).
○ Noncommercial – You may not use this work for commercial purposes.
○ No Derivative Works – You may not alter, transform, or build upon this work.

With the understanding that:
○ Waiver – Any of the above conditions can be waived if you get permission from the copyright holder.
○ Other Rights – In no way are any of the following rights affected by the license:
 ○ Your fair dealing or fair use rights;
 ○ The author's moral rights;
 ○ Rights other persons may have either in the work itself or in how the work is used, such as publicity or privacy rights.

Notice – For any reuse or distribution, you must make clear to others the license terms of this work. The best way to do this is with a link to the web page mentioned below.
 The full license text can be found at <http://creativecommons.org/licenses/by-nc-nd/3.0/nl/deed.en_GB>.

Author: Jeroen Lutters
Editing: Mieke Bal, Jeroen Lutters
Proofreading: Leo Reijnen, Els Brinkman
Index: Nic de Jong
Image editing: Mieke Bal
Design: Sam de Groot
Typefaces: Eldorado (William Addison Dwiggins, 1953),
 Computer Modern (Donald Knuth, 1984),
 SKI DATA (Tariq Heijboer, 2014)
Lithography: Mariska Bijl, Wilco Art Books
Printing and binding: Bariet/Ten Brink, Meppel
Publisher: Astrid Vorstermans, Valiz, Amsterdam,
 <www.valiz.nl>

Interviews Amsterdam 7, 13, 20 and 27 June 2016, recorded and transcribed by Michael Katzberg. Thanks to Esther Peeren and Jan Brand for their critical reading.

Creative Commons CC–BY–NC–ND

The images: © the artists / architects / photographers; 2018. All rights reserved.

For works of visual artists affiliated with a CISAC-organization the copyrights have been settled with Pictoright in Amsterdam, 2018.

The author and the publisher have made every effort to secure permission to reproduce the listed material—illustrations and photographs. We apologize for any inadvert errors or omissions. Parties who nevertheless believe they can claim specific legal rights are invited to contact the publisher: <info@valiz.nl>.

Distribution
USA: DAP, ‹www.artbook.com›
GB/IE: Anagram Books, ‹www.anagrambooks.com›
NL/BE/LU: Coen Sligting, ‹www.coensligtingbookimport.nl›
Europe/Asia: Idea Books, ‹www.ideabooks.nl›
Australia: Perimeter, ‹www.perimeterdistribution.com›
Individual orders: ‹www.valiz.nl›

This publication is kindly supported by ArtEZ University of the Arts, ArtEZ International Research School (AIRS) and International Master Artist Educator (IMAE), Art Based Learning Centre (ABLC), Arnhem–Zwolle–Enschede (NL).

ISBN 978-94-92095-56-5
Printed and bound in the EU

vis-à-vis

The vis-à-vis series provides a platform to stimulating and relevant subjects in recent and emerging visual arts, architecture and design. The authors relate to history and art history, to other authors, to recent topics and to the reader. Most are academic researchers. What binds them is a visual way of thinking, an undaunted treatment of the subject matter and a skilful, creative style of writing.

Series design by Sam de Groot, ‹www.samdegroot.nl›.

2015

Sophie Berrebi, *The Shape of Evidence: Contemporary Art and the Document*, ISBN 978-90-78088-98-1

Janneke Wesseling, *De volmaakte beschouwer: De ervaring van het kunstwerk en receptie-esthetica*, ISBN 978-94-92095-09-1 (e-book)

2016

Janneke Wesseling, *Of Sponge, Stone and the Intertwinement with the Here and Now: A Methodology of Artistic Research*, ISBN 78-94-92095-21-3

2017

Janneke Wesseling, *The Perfect Spectator: The Experience of the Art Work and Reception Aesthetics*, ISBN 978-90-80818-50-7

Wouter Davidts, *Triple Bond: Essays on Art, Architecture, and Museums*, ISBN 978-90-78088-49-3

Sandra Kisters, *The Lure of the Biographical: On the (Self-)Representation of Artists*, ISBN 978-94-92095-25-1

Christa-Maria Lerm Hayes (ed.), *Brian O'Doherty/Patrick Ireland: Word, Image and Institutional Critique*, ISBN 978-94-92095-24-4

2018

John Macarthur, Susan Holden, Ashley Paine, Wouter Davidts, *Pavilion Propositions: Nine Points on an Architectural Phenomenon*, ISBN 978-94-92095-50-3

Eva Wittocx, Ann Demeester, Melanie Bühler (eds.), *The Transhistorical Museum: Mapping the Field*, ISBN 978-94-92095-52-7

Ernst van Alphen, *Failed Images: Photography and its Counter-Practices*, ISBN 978-94-92095-45-9